Complete Guide to
Ultimate Digital Photo Quality

Complete Guide to
Ultimate Digital Photo Quality

Optimize Your Photos at Every Step

Derek Doeffinger

LARK BOOKS
A Division of Sterling Publishing Co., Inc.
New York / London

Book Design and Layout: Tom Metcalf
Cover Design: Thom Gaines – Electron Graphics
Associate Production Editor: Lance Wille

Library of Congress Cataloging-in-Publication Data

Doeffinger, Derek.
 Complete guide to ultimate digital photo quality : optimize your
photos at every step / Derek Doeffinger.
 p. cm.
 Includes index.
 ISBN-13: 978-1-60059-166-2 (pb-trade pbk. : alk. paper)
 ISBN-10: 1-60059-166-3 (pb-trade pbk. : alk. paper)
 1. Photography–Digital techniques. 2. Image processing–Digital
techniques. I. Title.
 TR267.D63 2007
 775–dc22

 2007018674

10 9 8 7 6 5 4 3 2 1
First Edition

Published by Lark Books, A Division of
Sterling Publishing Co., Inc.
387 Park Avenue South, New York, N.Y. 10016

Text © 2008, Derek Doeffinger
Photography © 2008, Derek Doeffinger unless otherwise specified

Distributed in Canada by Sterling Publishing,
c/o Canadian Manda Group, 165 Dufferin Street
Toronto, Ontario, Canada M6K 3H6

Distributed in the United Kingdom by GMC Distribution Services,
Castle Place, 166 High Street, Lewes, East Sussex, England BN7 1XU

Distributed in Australia by Capricorn Link (Australia) Pty Ltd.,
P.O. Box 704, Windsor, NSW 2756 Australia

If you have questions or comments about this book, please contact:
Lark Books
67 Broadway
Asheville, NC 28801
(828) 253-0467

Manufactured in China

ISBN 13: 978-1-60059-166-2
ISBN 10: 1-60059-166-3

For information about custom editions, special sales, premium and corporate purchases,
please contact Sterling Special Sales Department at 800-805-5489 or specialsales@sterlingpub.com.

CONTENTS

Introduction ■ ■

This book is not merely about how to take great pictures–it's about something even better. It's about taking ultimate quality photos–pictures that come close to achieving aesthetic and technical perfection. An ultimate quality photo represents the very best that you and your equipment can produce.

Following the procedures in this book will help you realize the full potential of your abilities and your equipment. This book will help you choose equipment and show you how to use it to maximize quality while shooting. This is critical because even the best equipment, when handled incorrectly, will yield poor results.

As a photographer, achieving ultimate quality images may well be the most challenging test you'll face, but the results can also be the most rewarding. With today's advanced digital cameras, superior lenses, and sophisticated software, there is enormous potential to create outstanding photographs. Digital cameras and LCD monitors help photographers to evaluate their photos on the spot, learn from their mistakes, and fine-tune techniques. But realizing the potential of this equipment is, in some ways, more of a challenge than ever before in the history of photography. There have been so many advances that there are now dozens of decisions that impact the quality of a photograph.

Digital cameras are computers that confront you with a myriad of functions and modes, which sometimes subtly, or very obviously, influence image quality. For instance, you must choose the file format, resolution, color space, focus mode, exposure mode, white balance, ISO, and more. All of these choices affect the end result.

It's important to remember that the camera is just one part of the picture-taking process. Also critical to the quality of the image is the device that forms it–the lens. As optical technology is refined for digital cameras, you're faced with more lens choices than ever before–these include lenses that were originally formulated for film cameras and others that are specifically designed to optimize the digital image. From the vast range of ultra-wide and wide angle, normal, telephoto, super-telephoto, macro, and high-speed prime lenses, to zooms, which also cover these ranges, you must select a few that excel for your needs. And even more important than buying the right lens is using it correctly. We'll show you the necessary lens techniques to create the sharpest pictures with your equipment.

But what about after you take a picture? Then what? Once again, the burden lies with you. You must adjust the image file in Photoshop or other software to optimize its exceptional quality. We'll show you critical software adjustments that will further preserve and enhance image quality.

And finally, with the image adjusted, you're ready to print it. Printing may be your greatest challenge. If you were in a triathlon, printing would be the swimming segment, the stage where you use a completely different set of muscles, or in this case, different equipment, thinking, and techniques that are unrelated to shooting the picture. Yet the expression of everything you've done up to this point, the proof of your achievement, depends on how well the print is produced. So step-by-step, we show you how to turn that ultimate picture into an ultimate print.

There's a lot to do. But before we jump into this book and learn to produce the ultimate quality image, we need to define what that is.

What is Ultimate Image Quality?

Simply put, an ultimate image looks outstanding. First consider the overall impact and impression the image makes on you. However, don't let composition, subject matter, and lighting distract you from also evaluating technical quality.

A superior image:

• Shows a wide dynamic range with appealing contrast while retaining detail in the highlights and shadows.

• Exhibits accurate colors with true neutrals.

• Reveals sharpness where you want it.

• Has enough data to make a big enlargement.

• Does not contain flaws such as noise, dust spots, and posterization; nor optical short comings such as flare, chromatic aberrations, vignetting, barrel or pincushion distortion.

You can create an image that will fully reveal your vision if you produce an ultimate quality photo. Creativity excels when you draw upon technical superiority. You may decide to take the image and oversaturate the colors, push the contrast beyond the pale, blur everything in a portrait but one eyeball, or run a myriad of mad software filters. That's your creative right.You may decide to gently lighten a red leaf on a rock in a stream and then boost its saturation and give it an extra touch of sharpening, while slightly darkening and blurring the stream and rocks around it. That, too, is your creative perogative. But to enable your creative prerogatives and realize an image's potential, you must start by taking the best photo possible. So let's look at the tools that help you achieve the ultimate image.

Choosing Ultimate Image Tools

Money or smarts? Technology or creativity? Superior equipment or superior skill? To the final question, the answer is both. To create great pictures, you need not only great vision but superior equipment. And more. You need to know how to master each and integrate them to achieve superior results.

Your Ultimate Camera

Should you get a camera with eight megapixels, ten, twelve, sixteen, or more? One with a vibrating dust reduction system to keep the sensor pristine and images spotless? Or maybe one with a CCD sensor instead of CMOS?

With thousands of built-in features how can you ever determine what the ultimate camera is for you? Fortunately, you don't need to find the ultimate camera; you need only find the camera that best fits your needs. Most of today's digital single-lens reflex cameras (D-SLRs) produce superb pictures that will enable you produce gallery quality prints. So let's start the task of choosing a camera that works for you!

Hold a camera and take some test shots before purchasing to see how its buttons and menus operate. Photo © Gary Whelpley

Choosing Your Camera

One of the best methods for choosing your camera and other photographic equipment is to investigate photography websites. Several give in-depth reviews of cameras, including evaluating image quality. Closely study the sample images they provide, focusing on sharpness and noise. A few sites review lenses and printers. Fewer still go into the techniques of creating high quality images. Of course there are endless forums where you can get personal insights and reviews, but these may lack the rigor applied by the formal review websites. Some of my favorite sites for camera information include dpreview.com, dcviews.com, steves-digicams.com, and luminous-landscape.com.

Criteria for Choosing a Camera

What should you look at in choosing a camera? The short answer is to find one that delivers the best image quality that you can afford. The long answer is to choose a camera that fits your budget, your skill level, and your particular type of photography. Carefully consider some of its key functions and features. Chief among those are:

- Sensor type (resolution and pixel size)

- Available accessories–lenses/flash

- Comfortable handling and ease of use

- Quality–enhancing functions

- Image stabilization

- Price

Does the Sensor Make a Difference?

Yes, the sensor does make a difference–a big difference! And the difference is just that–bigness. Physically big sensors are better. Big pixels are better. More pixels are better. There's a lot of discussion in digital photography that megapixel counts (quantity of pixels, or resolution) are not overly important. That may be true with compact cameras, but sensor size and pixel quantity can be critical with D-SLRs because they use higher quality sensors and, as we'll see shortly, mostly avoid the tiny pixels that hamstring quality in compact cameras.

All digital cameras use light-sensitive sensors filled with millions of pixels (picture elements) to capture the image formed by the camera lens. And all cameras use built-in software in the form of image-processing algorithms to convert the light into a color image that looks the way a photo should look. That software, proprietary to each camera manufacturer, has a definite impact upon image quality, but it's hard to judge that impact because the algorithms are integrated into the total image-processing system of the camera, leaving you to consider only a camera's overall image quality at different ISO settings.

Pixels are commonly described as buckets that collect light. That light is converted into digital data, a conversion that introduces a small amount of random information referred to as noise. That noise is revealed in a picture as a spray of erratic pixels that look like bits of colored confetti. It increases as you increase ISO and is most noticeable in the shadow areas.

So why is pixel size important? Because bigger pixels give better quality data than smaller pixels. They increase the signal-to-noise ratio, which means there is less noise in the picture. As pixel size grows and the pixel bucket becomes bigger and collects a lot of light, then the noise becomes a smaller percentage (and less noticeable in the pictures). Try to avoid cameras using sensors with pixels smaller than 5 microns. Look for cameras with sensors using pixels at 5 to 8 microns, bigger being better. The camera data sheet may indicate this specification. Some compact cameras cram tiny pixels, as small as 2 microns, into a sensor to increase resolution. The result is an increase in noise, most noticeable at ISO 400 and higher where compact cameras often deliver poor results.

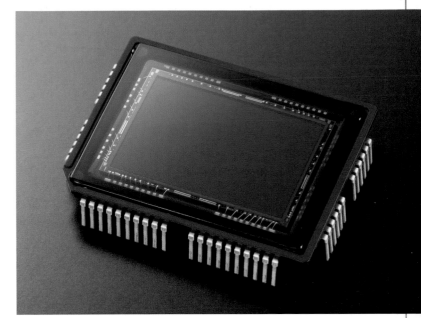

Find specification information to determine if the sensor's pixels are 5 microns or larger when you are choosing a D-SRL. Photo © Nikon, Inc.

Resolution is the number of pixels on a sensor. A million pixels equal one megapixel (MP). Advanced D-SLRs offer anywhere from 8 million to 16 million pixels. Medium-format backs offer 18 to 42 megapixels. These numbers are derived by multiplying the width of a sensor in pixels by its length in pixels. Thus if a room has square footage, you can think of a sensor as having square "pixelage." When you take a picture, the pixels are interpolated into files that end up approximately three times the size in megabytes (MB) of the sensor's pixel count. A 10MP sensor creates files of about 30MB; a 16MP sensor creates 48MB files (in the 8-bit mode).

What does all this mean? For one thing it gives a rough equation to calculate how big you can print an image. Although the dots per inch (dpi) for a high-resolution print can vary, we can use 240 dpi as an example. Divide that 240 into the sensor's pixel dimensions to determine the maximum print size you can print and still expect good quality. A 10MP sensor with resolution of 2592 x 3872 (divided by 240) will give a maximum print size of approximately 11 x 16 inches (28 x 40.6 cm).

A 16.7MP sensor with resolution of 3328 x 4992 yields a print that is about 14 x 21 inches (35.6 x 53.3cm).

Like auto mileage statistics for fuel, these figures are relative for comparison purposes. The actual print size you can make may vary with your particular camera, subject matter, and your subjective quality needs. Perhaps more important than delivering large print size, higher resolution cameras let you crop more area should your original composition require it.

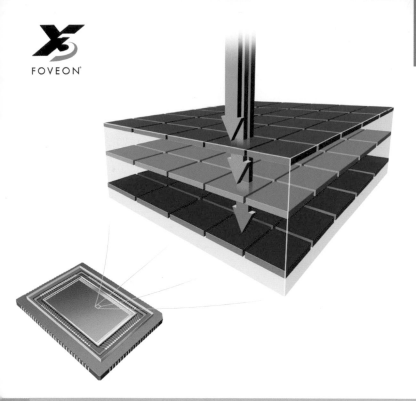

Illustration courtesy of Sigma Corporation. Foveon X3 is a registered trademark of Foveon Inc.

Foveon Sensor

One sensor differs from all the others and, theoretically, it should give better results. Color theory states that all colors of light result from various combinations of three colors: red, green, and blue. Together they make up the millions of colors we see. However, the vast majority of the sensor-types most commonly used in digital cameras, CCD and CMOS, have but one layer of pixels. So how can one layer capture three colors?

Coated atop the sensor is a filter array, usually a Bayer filter (named after its inventor). This array is a checkerboard of red, green, and blue filter patches with one color overlaying each pixel. It uses more green squares (50% green, 25% red, 25% blue) to better convey sharpness because our eye is more sensitive to green light. The data it captures is actually without color. The camera software interprets the data from the light received on the sensor to create a color image. Do you see a problem?

If one pixel is covered with a blue filter, it sees only the blue portion of the world, while its adjoining neighbors covered with green and red filters see the world as green or red. A sensor with a single layer is like a sieve that is holding only one-third of the total light information available–it has millions of holes in the form of missing color data. The sensor must make up new material to fill what it is missing. It does so by reviewing what each of its neighboring pixels sees. Using complex mathematical algorithms, the camera's image-processing system creates new data (interpolation) that in effect patches all the holes to create a complete picture with all the colors. Though the Bayer filter does a very good job, estimating color values that aren't really there can introduce image flaws, primarily the inability to precisely capture very fine detail. But a sensor that could capture all three color components (red, green, and blue) at each pixel site should give superior results, because no interpolation would be required.

That is exactly what the Foveon® sensor does. It contains three different pixel layers, with each layer dedicated to a specific color. No missing data. No interpolation required. Conventional sensors are one-color per pixel devices; the Foveon sensor is a three-colors per pixel device. It's an intriguing technology that hasn't yet caught on in a big way–in part because camera and sensor manufacturers have been able to overcome most of the shortcomings of traditional sensors. (The only consumer camera using the Foveon sensor is produced by Sigma.)

Note: Some video cameras for pros and advanced amateurs use three sensors to avoid the issue of interpolation: one each for red, green, and blue light. Fuji makes a CCD sensor that uses two pixels at each site, with one designed to capture shadow detail and expand dynamic range.

A lens used with an APS-C-sized sensor offers a cropped field of view compared to the same lens used with 35mm film (or a full-frame sensor). At the identical shooting distance, this effectively magnifies the subject, which can be great for telephoto work. Photo © Gary Whelpley

Full-Frame or Smaller Sensor?

The size of your camera's sensor, whether the same dimensions as a 35mm film frame (full frame sensor) or smaller, can have an impact on both quality and cost of your system, and it may require you to get new lenses. Full-frame sensors get their name because they cover the full imaging area of lenses designed for 35mm SLR film cameras. The full-frame sensor will allow you to use your 35mm film-camera lenses on your D-SLR with the same field of view they offered with a film SLR. That can be a huge cost savings, especially if you have high quality lenses.

Because full-frame sensors are expensive, many cameras use smaller APS-C sensors. But if used with 35mm style lenses, smaller sensors offer a cropped field-of-view that in effect magnifies the image delivered by the lens. This is known as the focal length magnification factor. On D-SLRs using APS-C sensors, that factor is about 1.5x or 1.6x. So a 200mm lens acts like a 300mm

lens. That's a benefit for photographers who use telephoto lenses, but it gives your 24mm wide-angle lens the field of view of a 36mm lens. So you're almost certain to need new wide-angle lenses if you pick a camera with less than a full-frame sensor.

You may also find that older lenses used with a camera containing a full-frame sensor fall short in image quality, causing excessive vignetting (light falloff at the edges) or other quality issues. Well-crafted lenses designed specifically for digital sensors, especially to match cameras with smaller sensor sizes, often give better results. They are usually designed to deliver the incoming light rays in a more columnated fashion, causing more rays to go directly into their pixel buckets. Older lenses send more rays at shallower angles, resulting in less light reaching some of the pixels. So some older lenses are more prone to vignetting (darkened corners), chromatic aberration, and possibly other lens flaws.

When to Buy a New Camera

Buy a new camera only when its megapixel count increases by 50% over your current model. If the increase is less than that, the difference in image quality will be hard to see. When the owner of an 8MP camera decides he or she is ready for a new camera, they should upgrade to 12MP or larger. Owners of 10MP-cameras should wait until they can afford one with 15MPs or larger. However, there's more to consider when getting a new camera than simply sensor resolution. Investigate several camera models to determine if other improvements in the sensor, processing system, or camera features would make it worthwhile to upgrade.

Image Stabilization

Although a tripod is still the best way to stabilize your camera, image stabilization technology does improve hand-held photography. A few D-SLRs offer image stabilization by shifting the sensor to counteract camera movement, but most, like Nikon and Canon cameras, rely on image-stabilizing lenses that move a glass element to counteract the camera movement. Although a valuable feature, image stabilization alone shouldn't determine which camera you get.

A Tripod Is Critical

Without a doubt, image stabilization systems in cameras and lenses are good. But tripods are better. True, using a shutter speed at least double the focal length of the lens is a good technique to decrease image softness. But a tripod is better. Yes, holding your camera on a railing or against a tree for extra support will give you sharper results. But a tripod is better. Nothing compares to a tripod in delivering sharpness. It helps images be sharper by eliminating the subtle blur caused by camera shake.

But which tripod is best? In choosing one, you must balance cost, combined camera-lens weight requirements, tripod weight, and effectiveness in holding your camera and lens steady. Putting cost aside for a moment, only firm support of your camera-lens combination can convey the superior sharpness of your lens and the high resolution of your camera.

If you regularly use heavyweight telephoto lenses, then your tripod (and tripod head) must be able to lock the camera down with nary a quiver when the legs are fully extended. That's asking a lot. If you normally use a much lighter wide-angle lens, you can get by with a lighter and less sturdy tripod. Tripod specs typically state the maximum weight they can support.

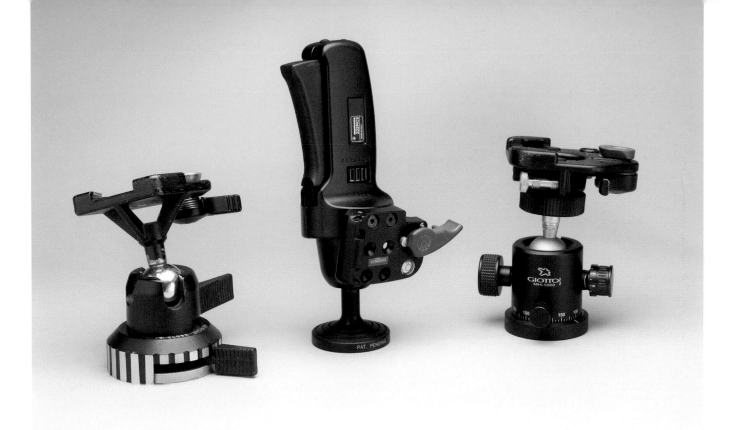

Tripod heads are available in a sophisticated array of styles and functions. Photo © Gary Whelpley

But don't rely just on a spec in a brochure: Be hands-on when shopping for a tripod. Take along the most demanding camera-lens combination that you regularly use and try it out. If a removable head is an option, be sure to test the head-tripod combination. Mount your camera-lens combination on the tripod and put it through the paces, simulating your normal usage. Orient the camera for both vertical and horizontal pictures. A good tripod head facilitates easy positioning of the camera in almost any orientation and may let you lock it down with a single hand.

If you haven't been a regular tripod user, don't overdo it by getting a tripod that is so heavy you'll end up leaving it at home. A medium-weight tripod may not give quite the stability of a heavy one, but it will likely give you good results most of the time. Unless you're backpacking or doing ground-level nature photography, avoid the small, lightweight models. Expect to spend several hundred dollars for a good tripod and head. The lighter weight and more rigid carbon-fiber tripods usually increase your cost by 50%. (Being a cost conscious person, I opt for aluminum tripods but yearn for a carbon fiber model.)

When choosing your tripod, test it against these criteria:

- Does it firmly hold your camera in both horizontal and vertical postions with your longest or largest lens attached?

- Can you can easily and quickly orient the camera?

- Does it offer for a quick-release adapter (small cylinder or plate that attaches to the camera and then locks into the tripod) for fast set up?

- Does it accept a separate head?

- Do the leg extension mechanisms work easily, quickly, and securely?

- Do set-up configurations meet your needs (some tripods offer a near ground level configuration)?

- What is the maximum height (without center pole extended) and does it meet your needs?

- Is it light enough for you to carry without a problem?

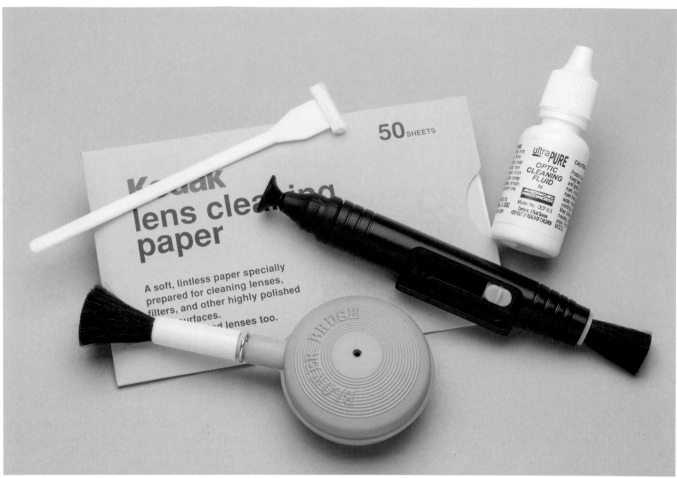

Photo © Gary Whelpley

Additional Accessories

There is a host of accessories offered to improve your photographic experience, so many different kinds it is almost overwhelming. Instead of covering the plethora of accessories, we'll look at the few basic extras that actually improve the quality of your photos.

Sensor Cleaners

We need a disclaimer here. You should follow the cleaning procedures in your manual so you don't void the warranty. You can also return your camera to the manufacturer for sensor cleaning, but that could take several weeks. Or take your camera to a local photo dealer who guarantees their work. If you want to do it yourself, know that any damage you cause could be costly and not covered by the warranty.

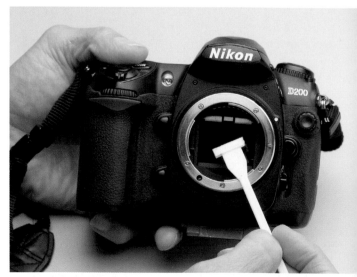

Photo © Gary Whelpley

There are a variety of special sensor cleaning products on the market that are similar to each other, and fairly expensive. An Internet search on cleaning digital sensors will bring up lots of information, lots of products, several do-it-yourself techniques, and lots of legal disclaimers.

You can use a bulb-type air blower to blow away loose dust. The sensor is covered by a clear glass filter so you have to be careful not to damage it, or the scratches you create will show up in your images. Don't use compressed air–it's too strong and the propellant might leave residue on the sensor cover.

If a blower doesn't remove the dirt, use a special brush made for cleaning the sensor cover at your own risk. Most D-SLRs have a sensor-cleaning mode that lifts the mirror and holds the shutter open while you do your cleaning. Perhaps more expensive than damaging the sensor assembly would be to damage the shutter if you don't follow procedure. Your manual will tell you to clean only when the battery is fully charged so that the shutter doesn't close unexpectedly and get damaged while you're cleaning. Again, read your manual and follow the procedure.

White balance tools such as these help you achieve accurate color in your photography.

Lens Cleaners

It is always handy to have an air blower, a lint free cloth (or lens cleaning tissue), and lens cleaning fluid. Use the air blower to blow dust and particles from the lens surface. Then squeeze a couple of drops of lens cleaning fluid on the lint free cloth and lightly rub the lens to clear it of fingerprints and other smears. Don't use treated-eye glass tissues/cloths because they can harm lens coatings.

Filters

You can now emulate a number of filter effects in the computer when processing your digital image files using applications like Photoshop® from Adobe®. Consequently the stable of filters required for your camera has fallen dramatically since the days of 35mm film photography. However, you'll still want a circular polarizing filter to handle unwanted reflections and to make fluffy clouds pop out from blue skies. You may want a neutral density filter to reduce the amount of light and enable long, water-blurring shutter speeds or wide-open, selective focus apertures. And a graduated neutral density filter can still come in handy to darken bright skies so you can balance them with the foreground, possibly saving yourself some image-processing work. If you're somewhat careless, go ahead and use a UV filter to protect the lens glass.

White Balance Tools

Most white balance tools consist of an assortment of cards containing precise spectral reflections of white, gray, or black. Others, like the ExpoDisc, attach to the lens. Both types let you set the camera to a neutral white before you shoot. The neutral cards can be placed in the scene so you can later click on them in Photoshop to set the scene color to neutral. The purpose of these tools is to improve color accuracy.

Quality through Your Lens

A good camera demands a good lens. Actually a good camera demands two, three, or even four good lenses. The combination of camera and lens forms a unit critical to the success of your photography. Together they create the image foundation upon which you build the final photograph.

In some regards, the decision about purchasing a lens is even more challenging than deciding upon a camera because there are so many lenses to choose from. Manufacturers of D-SLRs are few in number, and each makes only a handful of cameras. But lenses are produced by camera manufacturers and several independent lens makers, and they all make a great variety of lenses to cover the many applications of photography. The result? There are dozens of lens choices. And from these dozens, you must find a few that not only meet your budget and photographic needs, but also offer the quality required to deliver an ultimate image.

Choosing a Lens

Sharpness! Far and away, sharpness is the number one criterion for picking a lens. Is it sharp across its entire field and through all apertures? Is it extremely sharp at some apertures and soft at others? If it's a zoom, does it perform well at all focal lengths? Is chromatic aberration (CA) excessive? Is pincushion (straight lines curving inward) distortion or barrel distortion (straight lines curving outward) excessive?

Optical Qualities of Lenses

- **Sharpness:** Consider the lens' ability to reveal small details crisply from center to edges. Sharpness is similar to the more technical terminology of optical resolution, which often refers to a specific test pattern of line pairs with increasingly small distances between them.

- **Contrast:** Local contrast helps with sharpness. Overall contrast results in an image that pops. It results from optical design and materials that prevent light entering the lens from straying and causing a subtle flare or haze that degrades the image.

- **Geometric distortion:** This causes straight lines to bend inward (pincushion distortion) or outward (barrel distortion). Pincushion distortion is most noticeable with telephoto lenses, barrel distortion with wide-angle zoom lenses, and both are most objectionable with architectural subjects. This can often be fixed with image-processing software.

- **Chromatic aberration:** Often called color fringing, it appears as a color border along a high contrast edge. It results from the lens' inability (usually a telephoto zoom) to precisely focus all wavelengths onto the same plane. This can often be fixed with image-processing software.

- **Vignetting:** This results from the uneven distribution of light across the entire image. The expanded corner areas typically appear darker. This also can often be fixed with image-processing software.

- **Bokeh:** The way out-of-focus areas appear in a picture. Judging this is subjective, though pleasant bokeh is preferable.

Image-Stabilized Lenses

Image stabilization (IS) systems are sometimes placed within a camera's body, or may be found within certain IS lenses when using D-SLRs. Although the most important factor in choosing a lens is its sharpness, image stabilization can also be a key factor. You should use a tripod as much as possible, but given human weakness to take the path of least resistance (and not take a tripod with you at all times), image stabilization can be an important feature when deciding on a lens because blur from camera movement is a primary cause of poor image quality.

It's possible to fall into bad shooting habits if you always use image-stabilized lenses, leading to flabby photos (meaning they're soft and blurry). I do, however, recommend image-stabilization lenses (and cameras)–but only if you use them wrong. By wrong, I mean using them as if they were ordinary lenses without the steadying hand of technology. To use it as an ordinary lens means you shoot it at a shutter speed that is approximately the reciprocal (or faster) of the lens' focal length. For example, if using a 50mm lens, set a shutter speed of 1/60 second or faster; if using a 250mm lens, set a shutter speed of at least 1/250 second. Using this method you'll get near-tripod sharpness without the tripod (but a tripod is always best). Don't make a habit of shooting IS lenses at slow shutter speeds–you'll end up with mediocre sharpness. And don't hurriedly take a picture when using the stabilization. Focus and hold on the subject for a few moments. You should be able to see (and possibly feel) the system kick in. Once engaged, the camera will seem to hold steady on the subject so it doesn't appear to move while you look at it in the viewfinder.

With a 300mm lens and a shutter speed of 1/250 second, image stabilization (bottom photo) greatly improves sharpness.

Be sure to read the instructions for your image-stabilized lenses. More intelligence is being built into these lenses, so the day is coming when they'll work automatically in any situation. But in the meantime their effectiveness is often determined by an assortment of switches and functions. Some have to be turned off when used with a tripod; others recognize they're on a tripod and adjust accordingly. Some have to be switched for vertical or horizontal orientation, some for panning or moving subjects, and some can't be used with panning or moving subjects.

And finally, test your image-stabilization system at different shutter speeds to determine its limits. In the end, it may improve sharpness, but it's no match for a tripod.

More about Bokeh

Bokeh is a Japanese term that refers to out-of-focus areas. Depending on lens and aperture diaphragm construction, out-of-focus background highlights take on slightly different shapes, from a soft, pleasing disc to a harder edged hexagon, while other bokeh characteristics also vary with lenses.

Bokeh is both old and now. It's always existed but until recently hadn't been formalized as a lens quality to be concerned about. Japanese photographers elevated the pleasing appearance of the out-of-focus areas to a priority that has caught on around the world. It most often applies to the appearance of the background in telephoto pictures taken at a fairly large aperture—what we call selective focus shots. It's of greatest concern to nature and portrait photographers, and sometimes sports photographers.

It seems as if lens manufacturers are beginning to consider bokeh when designing lenses, which is a tricky task given the aesthetic nature of bokeh and the need to achieve high optical lens quality. If pleasing bokeh is important, you may be able to find assessments on the bokeh of particular lenses at test websites, and you can always go to photographers' forums to read different opinions.

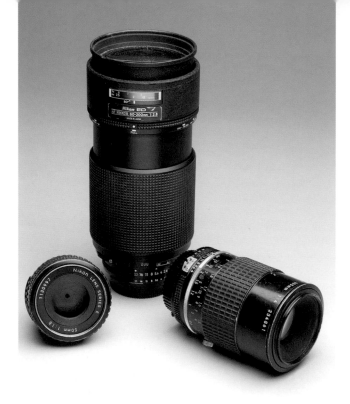

Photo © Gary Whelpley

See if the D-SLR manual indicates what functionality you might lose. Some D-SLRs offer adaptive features for older lenses by selecting an onboard menu and indicating certain specs of your older lens, while newer lenses are electronically integrated with the camera body. A number of lenses are now being designed just for digital cameras and, in theory, should outperform their counterparts designed for film cameras, enabling not only autofocusing, but automated metering, exposure setting, and communication with the flash (you may have to meter and expose manually when using an old lens).

In the end you can theory this and theory that, but theory stops where practice starts. Put your best film-based lenses to the test. If they meet your needs, use them. I still use my rather ancient, manual focus micro-Nikkor in Manual exposure mode on my digital camera. Why? Because it's sharp.

Older Film vs. Digital-Only Lenses

Sensors demand higher and sometimes different qualities from lenses than does film. So, should you continue to use older lenses originally made for 35mm SLRs? The answer is yes, especially if they are high-quality lenses that work with your digital camera and prove to be sharp when retested.

First review your D-SLR camera manual to make sure your old lens can be attached without causing harm. Some of these lenses have rear elements that extend too far and could damage the mirror when it flips up. Film-based lenses deliver an image that's bigger than the sensor area. That means most D-SLRs use only the central portion of the image delivered by these lenses. In theory, the central portion of the image exceeds the quality of its outer regions (vignetting and image softness usually increase at image edges). And since the light rays from the center of a lens will be at a steep angle, most of them should fill the pixel buckets.

Four Thirds Lenses

Yikes. Another thing to know. Four Thirds lenses are designed from the ground up to meet the requirements of cameras based on four thirds design principles. At this time, D-SLRs based on this design come primarily from Olympus. The name derives from the aspect ratio of the specific type of sensor used in these cameras, because the long side of the sensor is 4/3 (1.33) times the short side.

The declared advantage of Four Thirds lenses is their design, which is specifically for the requirements of sensors rather than for film, making them smaller and theoretically better performing. Four Thirds lenses deliver light perpendicularly to the pixels, pouring all the light into the pixel bucket like a faucet into a cup directly beneath it. You do risk that these lenses will become obsolete whenever competing sensors in the future commonly become larger than the most prevalent current size (APS-C dinensions). That may take several more years, but is the present direction of sensor technology.

Lenses can test your budget, but buy at least one high-quality lens for the type of photography you like to do most.

Trade-Offs in Choosing Lenses

If money is no concern, you can simply buy the best rated lens for your type of photography. But if the lens you dream about requires a home equity loan to purchase, then you need to make trade-offs when choosing lenses. The good news is that trade-offs won't hurt most of your photography. Ideally you could still purchase one superb quality lens to meet your highest priority photography. So analyze your photography and decide where you can make trade-offs.

For instance, you might judge that fifty percent of your photography will not put excessive demands on a lens (you mostly shoot within a moderate range of focal lengths at apertures well within the extreme settings), but about twenty percent of your work is for sports or bird photography that requires a super telephoto used with a wide aperture (a "fast" lens).

For the first scenario you could certainly find a moderately priced 3x or 4x zoom lens that performs nearly as well as more expensive lenses with features you don't need. But finding a super-telephoto lens that gives superb performance when shot wide open (f/2.8) for a low price won't be easy; in fact it may not be possible.

These are decisions only you can make because the debates and arguments can go on and on. Whether you're dealing with cost vs. quality, convenience vs. complexity, or other issues, don't expect clear-cut answers. But don't be afraid to make trade-offs.

For my landscape and still life photography, I shoot most pictures at f/8 to f/16, using a short-range zoom lens. I picked my lens by reviewing it on the several lens review websites. It scored well with some limitations. But when stopped down to f/8 and not shot at its extreme focal length ranges, it could rival the quality of far more expensive lenses. And in my personal testing against some high quality prime (non-zoom) lenses, it held its own.

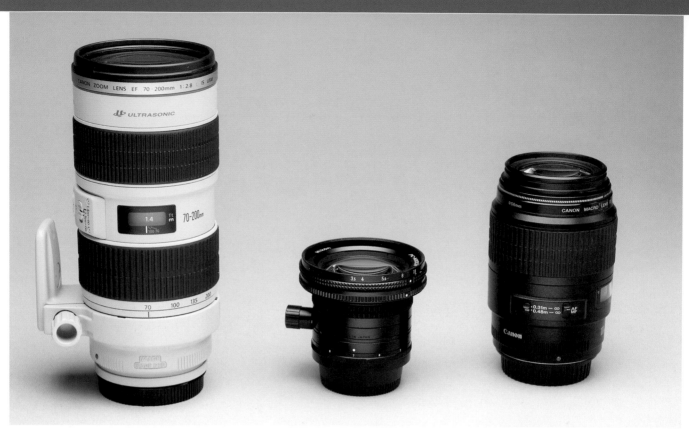

Specialty lenses usually cost more than general purpose ones, but give better results for the specific applications they address. Left, a 70-200 mm f/2.8 telephoto for sports or birding; center, a perspective shift lens for architectural photography; right, a macro lens for close-ups. Photo © Gary Whelpley

Specialty Lenses

The discussion about fast lenses for sports and bird photography brings up a good point. There are a variety of specialty lenses that give superior results in their area. If you are dedicated to a special type of photography, then achieving superior results requires specialized lenses. Know the lenses you need and buy them. This simple summary only hints at the types of lenses specialized photographers might need.

- Sports photography requires fast-focusing, large aperture telephoto lenses that can capture football players leaping over the goal in brilliant sunlight as well as boxers throwing punches in a dimly lit ring.

- Nature photographers need macro lenses designed to allow close focusing and still give superior sharpness–well beyond the domain of the all-purpose zoom lens. Image-stabilized lenses prove invaluable when backpacking or getting into positions difficult for a tripod.

- Architectural photographers need shift lenses that provide true perspective of the buildings they photograph, not the wildly distorted perspective of an everyday wide-angle lens that converges and bends the lines of a building.

Not all lenses are at optimal sharpness when used at the largest aperture (smallest f/number). That's why it's a good idea to test for accurate focusing

- Wedding photographers need a medium telephoto lens with a large aperture and image stabilization so they can sharply capture and isolate the beauty of the bride in a dimly lit chapel. A fast wide-angle to moderate telephoto would prove useful for switching quickly from overall group and scene setting shots to important pictures of individuals and details.

- Landscape photographers depend on a wide-angle lens that's razor sharp from edge to edge, capable of giving sharp results even at small apertures, with minimal light fall-off and minimized flare in bright sunlight.

Accurate Focus

Though we tend to take accurate focus for granted, I have a word of advice: Don't. Accurate focus is especially important if you are shooting with shallow depth of field. Shallow depth of field typically results from shooting at large lens openings (f/2.8–f/4), using long telephoto lenses for near and medium distances, and taking close-ups. Inaccurate focusing can result in unsharp photos.

A prime example is the use of selective focus to separate your subject from a cluttered background, perhaps a single plant in the forest or a bride at her reception. Especially in the second situation, you would almost certainly rely on autofocus to keep pace with the fast-changing environment. To make sure of getting the best results in such situations, test the focus accuracy of the lenses and focus modes you commonly use with your lens set to it's largest apeture (smallest f/number).

Avoid Broad-Range Zooms

Many zoom lenses with a broad range don't stand up to the highest quality needs, particularly those that cover from wide-angle to telephoto focal lengths. This is generally true of 6x zoom lenses (the focal length at the long end is six times that of the short end) or greater, such as 18-125mm and 28-200mm lenses. That's not to say these lenses won't have a sweet spot that can give good results, or that they don't make great travel companions when you want to travel light. It's just that with all the glass they carry, it's hard for them to match the quality of simpler lenses.

If you frequently use one or two zoom lenses, test them thoroughly so you can understand their strengths and weaknesses and to make sure they're capable of giving you exceptional image quality.

Zoom Creep

Beware of zooms that slowly creep and drain away quality. My sharpest zoom does just that. Perched on a cliff above Taughannock Falls, with my camera mounted on a tripod and pointed down at the falls below, I watched in wonderment as my zoom collar slowly slipped through the focal length range: 17mm, 24mm, 50mm, 70mm–gravity in action.

Not good. During long exposures, zoom creep can blur the picture. You can visually check your zooms for creep. With the zoom attached, hold your camera waist high in front of you and gently "saw" the camera up and down from your waist to your knees and watch to see if the lens slips and changes focal length. Some zooms have a zoom lock, a little slider on the barrel, that lets you lock the focal length.

Lens Review Websites

Several websites provide in-depth testing and analyses of lenses. Review these before buying a lens. Realize that they can't account for manufacturing variability. And since they can only test one or two lens samples, and if the manufacturing process isn't reliable, then the lens you buy may not live up to its testing. In that case, you could always perform your own tests. If it's an underperformer, return it.

The sites I commonly visit for new lens reviews are:

- www.slrgear.com
- www.photodo.com
- www.popphoto.com
- www.photozone.de

Note: Nikon shooters will enjoy a visit to www.naturfotograf.com. The site includes evaluations of a large number of older Nikon lenses.

Practical Lens Tips

- Buy at least one high quality single-focal length (primary) lens.
- Test and analyze your most frequently used lenses.
- Buy 3x or 4x zoom lenses, not 6X and greater.
- Use an f/stop two or three stops from the smallest possible on your lens.
- Avoid the extreme minimum and maximum range of your zoom lens.
- Use a lens hood.

Photo © Kevin Kopp

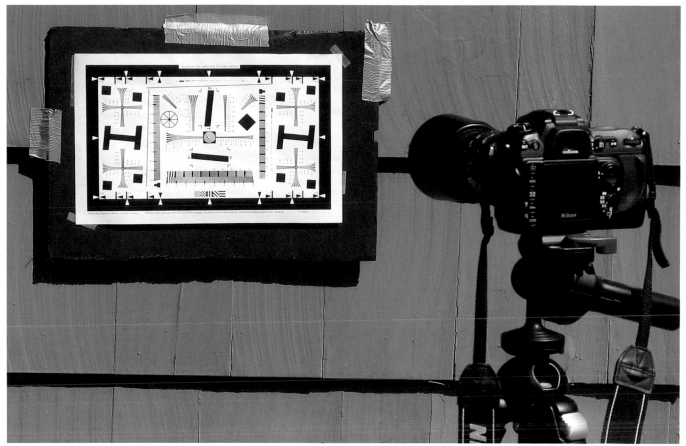

Test your lenses to find which one gives best results at particular apertures. You'll discover that one lens may be best for selective focus situations and another when you want increased depth of field.

Testing A Lens

You should establish a goal before you test lenses yourself. As a landscape photographer, my goal is to find two lenses that give the best results at wide-angle, normal, and moderate telephoto focal lengths when using a fairly small aperture for great depth of field. It may not be feasible to test all of your lenses, but the reason to do so is to determine which are actually the best. You could be surprised. I was and ended up buying a new 70-300mm zoom lens.

There are two ways to test: (1) The complete do-it-yourself method or (2) a method that uses a lens testing kit (which is still a form of do-it-yourself, but with someone else's methodology). The traits truest to a good tester include being thorough and methodical. We will be testing two variables: lens aperture and focal length.

I use both a resolution chart I downloaded from the web and a real-world subject that can challenge the lens. If you download a resolution chart, try to get a 16 x 20-inch black-and-white print made of it at a photo lab.

Finally, be sure to try your lenses with your favorite subjects, be they flowers, people, still lifes, or landscapes to make sure they pass both your formal tests and your real world shooting needs.

9. Manually focus the lens on the center part of the subject and do not change the focus during the test. If you're testing a zoom lens, test all the apertures at a single focal length and then move on to the next focal length and shoot another aperture series. You probably want to test a zoom at three to five focal lengths: the two extremes, the middle, and a focal length between the middle and each extreme.

10. Remove any protective filters and attach the lens hood.

11. Release the shutter via the self-timer, a remote, or a cable release. If your camera allows you to lock up the mirror, do so before taking the shot.

12. Shoot a blank frame as a later visual reference to indicate the start of the test series.

13. Take a test exposure with the lens set to its largest aperture and make sure the exposure is good. If you're taking pictures on a sunny day with a large aperture (small f/number), your camera may not offer a shutter speed fast enough to create a good exposure. If you face that problem, you can test on a cloudy day, indoors with studio lighting, or use the next smallest aperture that gives a good exposure with your fastest shutter speed.

14. Take your series of test pictures, starting at the widest aperture and then increasing the aperture in whole stops, such as f/2.8, f/4, f/5.6, f/8, f/11, f/16, f/22.

15. Check the histogram to be sure the exposure is consistent as you take the pictures. The histogram shape and position should stay about the same (slight shift is OK). If it shifts significantly, retake the picture changing the shutter speed to keep an exposure consistent with the other shots in the test series.

16. When you're done, shoot another blank frame to indicate the end of the series.

Redo steps 13-15 for each focal length of a zoom you're testing.

Lens Test Procedure

You can take test pictures in less than 30 minutes. Evaluating them on the computer for a single focal length will take a similar time. Comparing different lens tests on the computer may take an hour.

1. Mount your camera on a tripod.

2. Establish a position so that the subject nearly fills the viewfinder. If using a test chart, mount it on cardboard and position so it is parallel to the camera back without any glare reflecting from it.

3. If outdoors, make sure lighting is consistent and even. I prefer midday sunlight because it creates high contrast (shadow/highlight) borders that can challenge a lens. Choose a mostly front-lit scene, although moderate sidelighting is OK.

4. Record in a notebook the lens being tested and the picture series you will take. Number the shots. If you make a mistake, the file metadata should let you figure out the focal length and aperture used.

5. Set the camera to record RAW file format at the highest resolution.

6. Turn off the in-camera sharpening function (or set it to its lowest value).

7. Set the lowest ISO. Set the white balance to match the scene lighting.

8. Set the camera to Aperture mode.

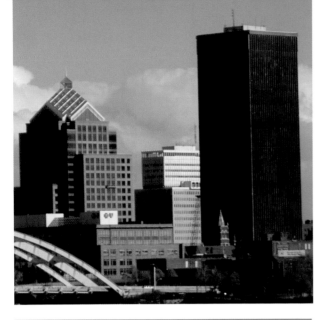

The result of this lens test becomes clear when comparing these two crops from the city skyline on the opposite page. The 70-300mm zoom lens clearly shown better sharpness at f/8 (bottom) than at f/4.5 (top).

Test Evaluation Procedure

1. Transfer the test shots to your computer and rename them with the lens manufacturer, focal length, and aperture used: example = Sigma30-f4.

2. Open the file shot at f/8, expecting (though not guaranteeing) that it may be the highest quality image to which you can compare other test images.

3. Next open the three or four RAW images shot at apertures wider than f/8 (images f/5.6, f/4, f/2.8).

4. If they don't show similar contrasts and brightnesses, adjust them to be similar

5. Save each file as a tiff or psd file.

6. Now open the images in your image-processing program.

7. Enlarge the image shot at f/8 to fill your monitor. Examine it to get a general impression (including contrast if it's an outdoor scene).

8. Enlarge the image to 100% and inspect it for sharpness and chromatic aberrations. Especially look at the corner detail and see how it compares to the center detail. If you photographed a resolution chart, note the smallest line pair that the lens can resolve.

9. Enlarge the image shot at the largest aperture (typically f/2.8 or f/4) to fill the monitor and examine it for vingetting, pincushioning, and barreling.

10. Enlarge that image to 100% and inspect as in step 8.

11. Next, postion the f/8 and f/2.8 (or f/4) images side by side and compare them at 100% for sharpness, resolution, and chromatic aberration.

12. Do this for all the test images, trying to identify the aperture that gives the sharpest results and fewest flaws. Note whether results at any apertures are so bad you should avoid them.

13. Make notes of your conclusions. Determine your lens' strengths and weaknesses, which f/stops give the best results, and which should be avoided.

If you have a couple of lenses with similar or overlapping focal lengths, test and compare them against each other. The name of the game is to eliminate variables other than the lenses themselves and the attributes you are testing. By doing this you should be able to determine which is your ultimate lens. If you're technically minded, you can buy a kit from imatest.com.

The Ultimate Computer System

The most important goal of your computer system is to enable you to accurately and consistently see, measure, and manipulate the color and tonal values of the image. Color accuracy reigns supreme. That means you need a system not only capable of delivering accurate color, but capable of incorporating color management. But you also need a computer capable of handling three or four large open image files simultaneously.

Choosing a Computer

It will not be news that your choices for computers are the same as they have been for years: An Apple computer with the Apple operating system, or a computer from one of the many manufacturers that incorporate the Microsoft operating system (the latest being Vista). The better-known computer makers using the Microsoft OS include Dell, HP, Gateway, and Lenovo.

Note: If you use an older printer or scanner, you may want to check that a Vista driver is available before updating from XP or an earlier operating system.

Apple or Vista? Does it really make a difference which system you use to handle your photographs? To some this is like asking, Harley or Honda, Mercedes or Cadillac, Evian or tap water?

Apple's stylish designs and their heritage of catering and effectively communicating to creative people have long made them a favorite of photographers. Their computers now use Intel processors and can even run a Microsoft operating system. If you find it advantageous to use both the Apple and Microsoft operating systems, then by all means choose an Apple computer.

The PC (computers running Microsoft OS), on the other hand, has long been viewed as a commodity without distinction. Few people wear T-shirts proclaiming affection for their Microsoft-based computers. I'm not going to endorse a type of system, because I don't think it makes much difference. In the end, you'll be doing nearly all your imaging work in Photoshop, and that program looks the same on both systems.

So how do you decide? In part you may base your decision on whether you do your photography for yourself or for somebody else. If for somebody else, how do they use your images? If you depend on them to further manipulate or output your pictures, then there may be advantages for you to use a system similar to theirs. While Photoshop files are interchangeable between Mac and PC platforms, the printing, advertising, and photo trades are still Mac-centric. So if you work with any of them, it may be more convenient for them if you work on a Mac.

However, Microsoft-based PCs still dominate the market with over 90% of computer sales. That means much of the world's computer infrastructure (at least those interested in profits) focuses on making life easier for PC owners, which leaves things less available for Apple owners. Don't let that frighten you from using an Apple, but keep in mind it's generally easier to find products, applications, and help for a PC. Because they are made in smaller numbers for a loyal constituency, Apple computers still command a premium price, typically costing about a third more than a comparable non-Apple computer. In terms of reliability, both camps like to claim superiority. A perusal of online and hard-copy sources that provide survey-based data on reliability may give a slight edge to Apple, but it's a target that shifts from year to year. So there's not a clear advantage to either system.

There are two additional things to consider about Apple. With the raging success of the iPod and iPhone, their attention is now focused elsewhere, so you shouldn't be surprised if their computers begin to suffer a bit from lack of attention. The other is that Apple owners are enthusiastically (even aggressively) supportive of their computers and its advantages. So take that into account if you get into a discussion with an Apple owner and don't let it unnecessarily influence you.

Laptop vs. Desktop

With a few exceptions, the choice between laptop and desktop is largely an issue of convenience or work style. If your photography requires a lot of travel or location work, then a laptop would make sense. Or if you are willing to take a laptop along when you photograph, it can be a boon to analyzing results (but a bane to the creative flow). The best of all possible worlds would include a laptop that supplements your desktop system.

Photo © Gary Whelpley

When working with large files, you will want a computer with enough RAM to take full advantage of all the tools in your image-processing program.

Minimum Specs and Configuration

Although increasingly powerful and certainly up to the task of processing image files if configured properly, laptop systems are still at a disadvantage to desktop systems if you don't need their portability.

- Laptops cost more. Configured similarly, the laptop will typically cost about a third more.

- They generally offer less expandability than desktops in terms of adding RAM, graphic boards, and so on.

- You'll need an extra monitor since most laptop dis plays don't yet deliver the critical color you need for image manipulation.

- Especially when in the field, reviewing the image on a laptop display lets you truly see its quality. A laptop makes perfect sense for most on-the-go photographers, but only the higher models can handle several highpowered image-processing programs at the same time.

Whichever computer system you go for, be sure to arm it with enough capability to handle large image files. Those big files (sometimes they'll be 100 megabytes) need a lot of computer power if you are to work efficiently. Computer specifications change almost monthly as new chips, better RAM, and other technologies rapidly develop. Still, you want to be near the high end in the evolving world of computer specs. Let's take a quick look at what such a system may currently contain, knowing that it's a moving target.

- RAM: 2 to 4 gigabytes (GB). Go for the higher end if you work with multiple large images or multiple pro grams simultaneously.

- CPU: Minimum of Intel Core 2 duo or AMD equivalent; quad chips are better, and eights top them.

- Internal hard drive: 400 gigabytes (7200 rpm with 16 MB or greater cache speeds opening and saving of images).

- External hard drive: 500GB; you need to back up your files regularly.

- Graphics board: 256–512 megabytes RAM for fast image display and excellent calibration potential.

- Card reader: Built-in card reader that supports SD and CompactFlash memory cards.

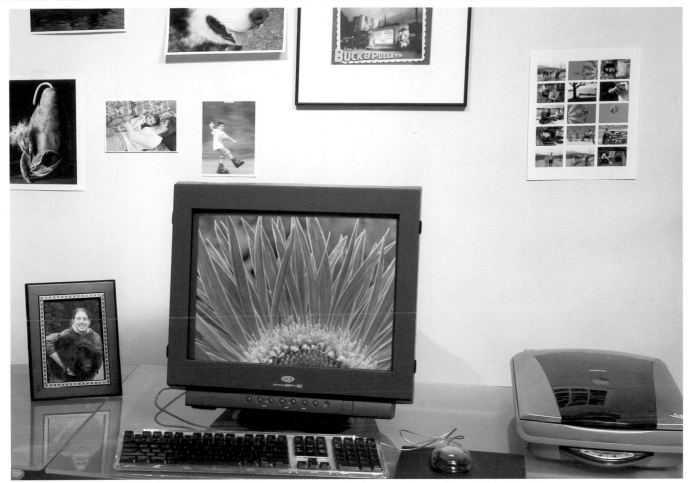

The highest quality monitor you can afford will be an advantage when adjusting your photos. Photo © Gary Whelpley

The Monitor

Once you've got the power, you need the precision. That's where the monitor comes in. The monitor is a critical component in adjusting images. Although you can analyze color and tonality with numeric readouts via Photoshop, photographers are a visual bunch and work best when the image they see represents the numbers generating them. So an accurate display will make adjusting images much easier for you.

From a technology standpoint, you have two choices: an LCD display or a CRT display. In the past few years, LCD (flat panel) monitors have overtaken the CRT in general popularity. Their light weight, portability, and sleek, stylish appearance seduce even the technophobes. And certainly they are beloved and pushed by merchants and techno journalists, who are naturally attracted by the latest developments

But the CRT hasn't quite given up the ghost. It continues to offer consistent, accurate color, a wide gamut, great shadow separation, and a broad viewing angle. CRTs also work well with calibration software. Perhaps the biggest problem with CRTs is that there are so few models made anymore. Home-computer users have emphatically voted via their purchases for LCD panels, and manufacturers have responded by expanding the number of LCD models while shrinking or discontinuing their CRTs. It may not be long before your only choice is to get an LCD panel. Indeed, Apple has increasingly integrated computer and display, and no longer offers a CRT monitor.

Go for a large monitor after you've decided on the type, LCD or CRT, that you prefer. You not only need a high quality display, but ideally a big one for ultimate image

manipulation. A big monitor conveniently lets you deal with multiple images simultaneously and also allows you to enlarge the image while still viewing much of the entire picture, so you aren't working on a single area of a photo in isolation. And a large screen lets you view more area at greater magnification, so you don't have to scroll or zoom so much to review your work.

What's the smallest display that would be suitable? A minimum is 19 inches (48 cm), but preferably 21 inches (53 cm) or larger. Screens of 24 inches (61 cm) are becoming common, and super-large displays spanning 30 inches (76 cm) may tempt you. But perform a trial when first trying a big monitor to see if you need to sit farther back than normal to comfortably view the entire screen.

Some folks work with two monitors. On one they place the toolsets and on the other the enlarged image. That's fine. And quite simple if you don't need to match the two monitors in quality. But ideally you would get two of the same kind of monitor so your displays match and don't cause color adjustment problems (because your eyes are constantly trying to adapt from one monitor to the other). Two different monitors would likely influence how you perceive color and then how you adjust images. So one big display is the easiest and most affordable way to go.

Affordability may be the biggest issue of all. Good monitors are relatively low cost, currently in the $300-$600 range. Going from good to top-notch may double, triple, or even quadruple that cost. First-rate monitors may cost as much as your computer or your camera. It can be a tough decision to spend such a big sum on a display; that's money with which you could buy a new camera or go on a trip that would yield exceptional pictures. If you have the money, go for a top-notch monitor. Display companies who pride themselves on high quality include Sony, Eizo, and LaCie. Other quality brands include Apple, Samsung, and NEC.

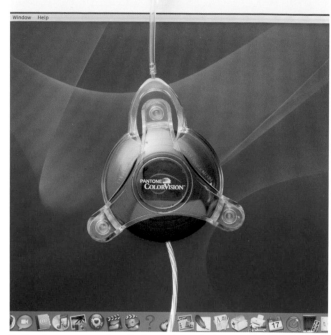

Calibrating your monitor display with a colorimeter (shown) and its supplied software is vital to acheive accurate color. Photo © Gary Whelpley

Calibrating and Profiling Your Monitor

Your monitor reigns as the pivot point for everything you do after taking the picture. If it doesn't display your picture with high fidelity, your time spent adjusting images will be increased. So calibrating and profiling are critical because they can improve the display accuracy of even a high-priced, high-quality monitor.

Just about everybody who writes about calibrating monitors uses the same analogy: They mention the wall of televisions at an electronics store. We've all seen it. You walk into a big-box electronics store, see all the television screens showing Shrek or an old Super Bowl, and you notice one thing: No two displays look alike. Which means if one is accurate in its color display, then all of the others are inaccurate (or maybe none are accurate). And that makes you wonder about your own monitor. How do you know if it is displaying accurate color? You may look at your monitor and believe that the whites, grays, flesh tones, and other colors look good, but you're really like the carnival guy guessing somebody's weight–you don't really know until you

accurately measure it. With color, you determine accuracy by working with calibration tools. Only these types of tools can give you confidence that your monitor is displaying accurate colors and distinguishing the many tonal values, especially those deep blacks and light whites that you need to show the all-important detail in shadows and highlights.

The calibration process sends precisely known colors to your graphics card and directs it to convey them to the display. Will the monitor then accurately present those known colors? Probably not yet. There's enough variation in the materials and manufacturing to cause inconsistency in color output. This is where profiling comes in. You use a technical measurement-system to identify your display's output variations and adjust the signals coming from the graphics card to compensate for variations and thereby produce accurate color.

duces. The software then compares the measurements taken by the colorimeter to the values that were supposed to be produced. It accounts for the differences and creates new "color mixing" instructions that enable the monitor to more accurately create colors. These color-mixing instructions are known as a monitor profile.

By calibrating and profiling the monitor, you make it predictable, consistent, and accurate. An accurate color display will let you precisely adjust your images in Photoshop or other software to produce photos with correct colors and a wide dynamic range with details throughout. Most color management products recommend you update your monitor calibration monthly. Kits like this cost from $150 to $400 and provide the necessary tools for do-it-yourself color management. Products in this category include ColorVision Spyder2, Eye-One Display 2, and Color-Eyes Display Pro.

Instrument-Based Color Management

Instrument-based color management is a scientific method of calibrating and customizing the devices (and the workflow process) that handle your color pictures so you can consistently and predictably get the print results you desire. To calibrate and profile your monitor, you can purchase software and a colorimeter. Install the software and then place the colorimeter, a tomato-size device, on the monitor to measure the values of the colors displayed. A wizard leads you through a series of steps to calibrate your monitor's brightness, contrast, and color reproduction.

After you calibrate the monitor, you need to profile it. That means you need to create a custom set of directions that tells your monitor how to accurately reproduce color. The software you installed instructs the monitor to produce a wide range of specific colors. The colorimeter measures the colors your monitor repro-

sRGB color space; 8-bit depth.

Adobe RGB (1998) color space; 8-bit depth.

Thoughts from a Color Management Pro

Text and Photos by Michael Brown

Implementing ICC-based (International Color Consortium) color management can improve your efficiency in the digital darkroom. The three profiles needed in a typical ICC workflow are: input, monitor, and output.

Most photographers are now using digital cameras and don't bother with a custom ICC input profile. If they are shooting JPEG, their files will generally already be in the sRGB color space. Most D-SLRs let you select Adobe® RGB (1998), which offers a wider color space than sRGB. Although in theory this selection offers better results, in many cases you will not see a big difference between the common color spaces. However, if you want to squeeze out the last ounce of quality, you probably should work in the ProPhoto color space, because it is the largest. I suggest testing to see if a wider color space improves results for your type of photography.

Even more important than the color space you select is taking correctly exposed, color-balanced images. I'm a big believer in shooting RAW files and testing a gray balance on a known neutral within a scene. I like to keep a Greytag MacBeth Gray Checker handy when I'm doing studio work, and I keep a small gray card in my backpack when I'm out in the field. By capturing a correctly exposed RAW file with proper color balance, I save processing time compared with struggling to edit a JPEG file in Photoshop.

With most photography, the differences between color spaces are not very noticeable. I might be a contrarian, but I actually think the sRGB color space is fine for most photographing because it is such a widely supported standard. I've met photographers who discredit the use of sRGB based on a talk they've heard or a book they've read, though I've yet to speak with one who has actually run tests with their own images. The only time I create a custom camera input profile is when I'm photographing fine art for reproduction under controlled studio conditions. I find in that scenario that a custom profile really helps to accurately match a reproduction to the painting's original color.

sRGB color space; 16-bit depth.

Adobe RGB (1998) color space; 16-bit depth.

ProPhoto color space; 16-bit depth.

Historically the best and most accurate monitor displays have been the older heavy glass ones using cathode ray tube technology (CRT). Although such displays have wonderful image quality when calibrated, the world has bypassed CRTs in favor of liquid crystal displays (LCD).

After purchasing your display, the most important step is to calibrate it with a colorimeter. Most users will choose a color temperature of 6500 degrees and a gamma of 2.2. These are excellent starting points, but you should test your workflow. If those settings don't work for you, find out why, and change them.

To me the most critical ICC profile is the output, or printer profile. Canned or reference profiles are provided by many manufacturers for their desktop printers and media. I find most of these profiles are quite useable. However, I have always been able to get better results by taking the time to build a custom output profile for a specific printer, ink, and media.

I see many photographers struggle to set up their print drivers correctly. If someone with good equipment is getting poor results, I generally find that their print driver is set incorrectly and they are either not

doing an ICC-based conversion or they are converting the image twice by mistake. Usually by spending a few minutes with them, we can get their printer to sing. Spending a little time to learn about and set up an ICC-based workflow will pay great dividends.

Michael Brown installed color management systems in professional photo labs for several years. He now makes and sells his own fine art-prints.

A densitometer (used with software) profiles your printer by measuring and adjusting printed color samples of known values. Photo © Gary Whelpley

Profiling Your Printer

If you want to close the color quality loop, the next step is to profile your printer so it produces prints that closely approximate the image you see on your monitor. Colors that reflect from ink drops on paper differ greatly from those glowing on your monitor. But you can make them approximate each other by profiling your inkjet printer for various combinations of ink and paper, and then use Photoshop proofing to simulate on the monitor what the printed output looks like.

Profiling your printer means you're actually measuring how it creates the colors of your photos by applying specific inks on a specific paper. The measuring device for checking colors on an inkjet print is a densitometer. Instead of measuring a random photo, you will be asked to print a file containing a grid of specific known colors. The densitometer then measures the actual colors that were printed and sends the measurements to a software program. The software compares the actual colors produced with what should have been produced. Based on the differences, it creates instructions (the profile) that tell the printer how to adjust its ink output to create more accurate colors–but only for that specific paper-ink combination.

Since ink interacts differently with each paper type, you need to create a profile for each of the different papers you regularly use. The profile is a small file of software that you select before printing, much the same way you used to select the type paper you were printing on using the driver.

How difficult is this, and how effective? It's not very difficult in my experience, and it's fairly effective. Many paper manufacturers provide paper profiles for specific models of printers. When you install the software (print driver) for your printer, you are also installing these paper profiles provided by the printer manufacturer. You can enable these profiles through the printer driver or Photoshop, and they perform reasonably well to very good. But since your printer is a unique device, developing profiles specifically for it should give you even better results. The real issue arises when you use a paper for which you have no profile or no suggested settings for the printer driver. Then it becomes a trial-and-error process.

Professional Color Management

If you want the advantages of color management without the hassle of figuring it all out, you can spend a few hundred dollars to have a pro do it. The installation process will probably be done faster and better because you won't have to solve the problems that inevitably occur. The professional will likely give you a quick training session, which is not a bad way to start out with a new color management system.

If you're happy with your monitor's display accuracy but want to try some new papers, get a profile for each new paper. Many paper manufacturers provide free downloadable profiles on their websites. You can also buy generic profiles for a variety of paper-printer combinations, or even print a standard color patch and pay $50 to $100 to create a custom profile based on the results of the patch made on your printer-paper combination. You might think a profile is a profile, but the equipment, science, and craftsmanship that go into a profile can make a big difference in how your prints look.

Photo © Gary Whelpley

Image-Adjustment Software

The initial step in choosing software is easy. Just buy Photoshop CS. It's so close to being a standard, and its functionality is so capable, that it serves well to use it as your primary software for adjusting images. Although you can get by with the more basic and inexpensive version, Photoshop® Elements, Photoshop CS lets you tap deeply into the potential of your images. It gives you the tools to open and adjust the all-important RAW files as well as JPEG and other popular image formats. We'll discuss software much more in the section on Adjusting the Ultimate Image.

Of course, you can always order a professional paper profile from a professional lab for a fee of $50 to $100. They will provide a file with a series of color patches that you print with the paper you want to profile. You send them the print, and they measure the values of the colors your printer produced, compare them to what the colors should be, and use the differences to create a profile of your printer.

The Viewing Environment

Now that you have a good monitor that is calibrated and profiled, you must take one more step to assure the fidelity of the image it displays. You should prevent external lighting from "staining" the display, from misleading your vision with lighting that is off-color or too bright. You should create a dim environment where walls are neutral gray so they don't throw a color cast on the computer display. Windows need shades so you can block bright daylight from striking your monitor when you're working. Many high-quality monitors come with a hood to block extraneous light. If your monitor is hoodless, you may want to make your own using foam board. And there's one final threat to color fidelity on your monitor: You. Before sitting in front of your monitor, doff those colorful golf shirts for a plain dark shirt that won't reflect unwanted color onto the screen.

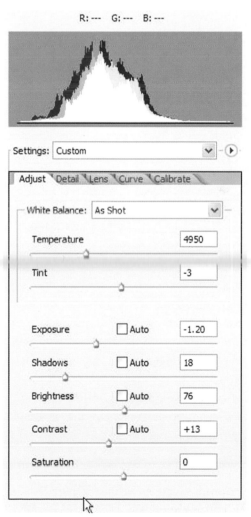

This screen shows the interface for Photoshop Camera Raw, which allows you to view and adjust settings for RAW photo files.

Photo © Gary Whelpley

Inkjet Technology

Choosing an inkjet printer to produce superior photos is actually fairly easy, simply because your choices are limited. Although the average consumer may be faced with hundreds of printers, you, as an ultimate printer, will have only a handful to choose from. You'll be pretty much on your own to pick a printer since few websites give thorough coverage to high-end inkjet printers.

Epson in particular positions itself as the manufacturer of incomparable printers for high-quality photographs, and it may actually deserve this title. Epson probably owns 80% or more of the market for high-quality photo printers. That means producers of ink, papers, profiles, software, and other high-end supplies customize their products to appeal to Epson owners. No small advantage. In addition, two other manufacturers who compete at the high end of photo printing are Canon and Hewlett-Packard.

Printers have become so advanced that you almost can't go wrong with a known top-notch model. You might think you have to carefully weigh printer specs, but with the possible exception of speed, that's not necessarily so. Things like dpi, ink-dot size, and number of

ink colors may vary somewhat among the frontrunners, but they all have one thing in common: superb quality. Even though Epson has built a reputation around professional photo-quality printing and has nearly become the de facto printer of professional photographers, be sure to consider models from HP and Canon before you buy a new printer. Recent introductions show they're also making superior printers.

Criteria for Choosing a Printer

- **Quality:** Seeing sample prints is best. Especially look for the ability to create smooth tonality in uniform areas, such as skies and flesh tones. Quality nominally derives from having a minimum of eight ink colors (two different black or gray inks), small ink dots (less than 4 picoliters), and sophisticated placement (dithering) of the tiny colored ink dots so they continuously convey a wide color gamut (with neutrality) from shadow to highlight.

- **Color or black and white:** Not all printers can do both well. If you want to make black-and-white prints, you're entering another world—one that continues to change rapidly. Research carefully by going to websites such as luminous-landscape.com.

- **Size:** You have choices from letter size (8.5 x 11 inches; 216 x 279mm) to tabloid (13 x 19 inches; 330 x 483 mm) to wide format (17 x 20 inches; 432 x 508 mm; or bigger with lengths up many feet if the printer uses roll paper).

- **Speed:** Time is money. If you're making dozens of prints, you may want a fast printer with high capacity ink containers.

- **Longevity:** Most printers now make prints capable of lasting 100 years or longer. Prints made with pigment inks last longer than those made with dye inks. Paper-ink combinations can have different effects on permanence, a factor manufacturers harp on so you'll buy their products.

Print quality is generally excellent with high-end printers. When buying a printer, make sure to check out mechanical reliability.
Photo © Gary Whelpley

- **Cost:** Expect to pay $300 for a letter-size printer, $400 to $800 for a tabloid size printer, $1000 to $3000 for a wide-format printer.

- **Paper:** How many papers are available from the manufacturer? Epson has a large variety, HP a modest variety, Canon only a few. But independent paper suppliers offer a huge number of choices. Another question to ask is whether the printer can handle thick art papers, or if you even care.

If you're an in-depth researcher, you'll find other factors that enter into the equation. For instance, some printers now can print 16-bit images with a plug-in–that can give you extremely smooth tonality and extend the gamut in some areas. You'll want to find information on factors from printer reliability to the capability of the print driver.

Piezo Vs. Thermal Printers

Not only do inks come in pigmented and dye-based varieties, the method for applying the ink comes in two technologies: piezo and thermal (bubble jet). Epson uses the piezo method, which applies electrical current to a tiny crystal in the ink head. The crystal changes shapes and pushes out a droplet of ink. The advantage is that the ink is not heated, so inks can be designed without having special properties to withstand high temperatures. In addition, the size of the ink drop can be quite small for greater precision.

Canon and Hewlett-Packard use thermal technology. Electricity heats a tiny resistor in the ink head that literally boils the ink (an infinitesimally small amount) to form a small bubble that pushes out the ink. Ink ingredients must be able to withstand temperatures up to 1000 degrees Fahrenheit (538 degrees Celsius) for a microsecond. That excludes many chemicals and solutions.

Both Technologies are very good and you'd be hard pressed to see differences in prints resulting from them.

Printers vary in printing speed, styling, and ink efficiency. Do your research to choose the printer that is right for you.
Photo © Gary Whelpley

Cost of Supplies

Cost is hard to ignore. The cost of a single sheet of 8 x 10 inch (203 x 254 mm) photo paper ranges from fifty cents to three dollars. The cost of photo paper tends to be a reflection of quality. Since you can use inkjet paper in your printer from a variety of manufacturers, you can usually find one that gives you the right combination of price and quality and longevity.

Ink is another matter. What does ink have in common with gold, diamonds, and caviar? Believe it or not, ink by weight costs even more than those items.

In general, you should stick with the inks made by the maker of your printer. Most manufacturers discourage the use of third party inks by voiding the warranty should any damage result. Choose a printer that allows you to get the most out of your inks for a reasonable price.

Some manufacturers provide different colors of ink in separate, individual containers that can be replaced when one color runs out. Others combine the ink colors into a single, integrated unit that forces you to replace the entire package when one color runs low. These design considerations affect cost and consumer psychology, since the idea of throwing away costly unused ink can be quite annoying

But manufacturers who put inks in individual, replaceable buckets are also playing a psychology game. They want you to think that you are saving money when you replace just the ink color that runs low, but that is not necessarily so. If those individual tanks are expensive, you may not save anything. How inks are contained tells you nothing about how efficiently the printer uses them. Like a fuel-efficient car, some printers get a lot of mileage from their inks through effective application. The cost for their cartridges might be high, but they can be economical on a cost per print basis.

Quick Summary Guide:
Tips for Choosing Ultimate Equipment

Tip	Comment
Read camera and lens review sites to start your evaluation process.	Many good websites and magazines available.
Get a good tripod.	It's the enabler of ultimate sharpness potential.
Upgrade to a higher megapixel camera only if it offers 50% more pixel resolution.	For example, upgrade from an 8MP camera to a 12MP camera. Less than 50% increase in resolution is not very noticeable in prints.
Choose a camera with 10MP or higher.	10MP or higher is best to make prints 11 x 14 inches (28 x 35.5 cm) or bigger, or to enable meaningful cropping.
Make sure pixel size on sensor exceeds 5 microns.	Small pixels cause image-degrading noise. High megapixel sensors with small pixels create excessive noise at sensitivities higher than ISO 200.
Choose a lens first on its sharpness.	Sharpness is the most important quality.
Buy at least one good lens to meet your most critical photo needs.	Evaluate your shooting needs to determine the lens focal lengths you need most.
Buy white balance tools so you can achieve neutral white balance at picture-taking time.	It's a simple one or two-step procedure that can save you software-adjustment time.
Avoid zooms with a focal length range of 5x or greater.	Few zoom lenses with a range of 5x or greater (e.g., 18–135mm) can meet ultimate image quality needs.
Buy a high-quality monitor and get a monitor calibration system.	Accurate colors on the monitor and throughout the system are key to adjusting images.
Determine what size prints you want and what your budget is for a printer.	Not all printers are able to print bigger than letter size. Tabloid-sized printers cost more than letter-sized.
Research printer specifications before buying.	Make sure you get what you want and need. How long does it take to print a color 8 x 10 at highest resolution? How many ink cartridges and what is cost for replacements? Can you print 16-bit images? What is the longevity of a manufacturer's paper/ink combination?

Just as Tiger Woods or Ernie Els adheres to a specific set of practices before swinging at a golf ball, so should you follow a specific preparation plan for taking a picture.

Using Your Camera

It pays to know your camera well, especially those functions and features critical to delivering quality images. Let me give an example. When I started working on this book, I was comparing lens tests and discovered unexpected blur at a slow shutter speed with a long telephoto lens, even though my camera was mounted on a tripod. I had even been using the self-timer to avoid jarring the camera. I thought the problem was the result of vibrations from the viewing-system mirror flipping up after pressing the shutter button. How could I eliminate that? Well, I could put the mirror up before taking the picture, but then the camera's self-timer wouldn't work, and I didn't have a remote control or cable release. I read the manual and found a function that delays the camera from releasing the shutter until about two seconds after the mirror flips up. It worked. No more blur from vibration induced by the mirror movement.

Your D-SLR probably has hundreds of features, functions, and settings leading to thousands of potential combinations that affect image quality. But don't be intimidated. You only need to learn a dozen or so key settings that have an impact on your image quality. Learn them by closely reading your manual or by picking up one of the *Magic Lantern Guides*® books or videos for your model of camera. The guides go into full detail about the functions of the camera and are an invaluable resource. You have a major advantage when the ability to find and set these critical functions becomes second nature.

Make it your goal to learn how to find and change the settings for the following functions:

- File settings for resolution, RAW file format, JPEG optimization (quality or compression)

- ISO

- White balance

- Metering modes

- Manual focus

- Manual exposure mode

- Self-timer

- Mirror up (may not be offered by all cameras)

- RGB color mode

- LCD display functions

- Histogram display

- Image magnification on LCD

Quick Guide:
Prepare to Shoot

Follow these guidelines to systematically improve the quality of your photos.

1. Make sure the battery is charged and the memory card is nearly empty.

2. Shoot RAW file format.

3. Set the largest file size.

4. Use the lowest ISO setting (unless photographing fast action).

5. Use Adobe® RGB (1998) color space if you intend to make prints.

6. Use a single-focal-length lens or your best zoom lens. If using a zoom lens, try to avoid either the maximum or minimum zoom setting.

7. Set the optimal aperture, usually mid-range f/stops such as f/8 or f/11 (when not using selective focus or trying to achieve maximum depth of field).

8. For maximum depth of field, use the second or third smallest aperture (high f/number) available, such as f/8 on a wide-angle lens, f/11 on a normal lens, or f/16 on a telephoto lens.

9. Use a lens hood to shade the lens from extraneous light.

10. Use a tripod.

11. Instead of pressing the shutter button and risk jarring the camera, use a cable release, remote control, or self-timer.

12. Start with exposure compensation at zero.

13. Use the camera histogram to verify that you achieved a correct exposure.

14. Bracket exposures in high-contrast lighting. Shoot up to five 1-stop variations. Use a tripod if you want to use High Dynamic Range (HDR) in Photoshop to combine images (see pages 60-61).

15. Use compositional bracketing to minimize cropping later.

The Advantage of RAW

Taking a picture using the RAW file format is like taking an exam at home with an open book, but better! That's because you can change your answers (or digital settings) not once, but many times. You can even change your answers after you have completed the exam–in this case after you've applied the amount of processing you choose to your image file and saved it. How great would that be, changing the answers days after you took the test?

A RAW file collects a variety of data at the time you take the picture. It does so by recording most of the information without processing it. So after you take a photo, the RAW format lets you change nearly all the digital, or "soft," settings in your computer when you open the picture using your RAW software application. Among the settings you can modify are exposure, white balance, saturation, color mode, contrast, and resolution. You adjust these attributes using appropriate software after transfering the picture from your camera to the computer. That means you can make changes that don't affect the underlying pixels. The end result is a superior picture. Using RAW, you retain the original pixel information in the file so you can change digital settings to create different versions of your RAW image file. This is important because if you discover that exposure or color balance, for example, are less than optimal in a JPEG file, you can only adjust them by making changes to the pixels in the file, which reduces the quality of your pictures.

The RAW file format lets you make color and tonal adjustments without losing original picture data. This photo, taken at sunset, shows the building's actual appearance at sunset (right), and how it might appear at midday (left) by adjusting the white balance.

It is true with RAW that you can't change the actual hardware settings, such as focus, aperture, and shutter speed. And unlike photo file formats such as JPEG and TIFF, which are standardized in their structure, the RAW file format differs among the various manufacturers who implement their version in their cameras. This leads to variations in quality of different RAW files, and means image-processing software from Nikon won't open Canon's RAW files (and vice versa). However, Photoshop® Camera Raw and other third-party RAW software programs will open RAW files from most of the camera companies.

Are you beginning to understand why the RAW format is important? If you're a pessimist, you might think it's important because it lets you rectify mistakes or oversights you made during picture taking. If you're an optimist, you see it's important because the pictures you take now might become even better in the future when RAW software that opens and develops these files is improved. And if you're a perfectionist (or ultimate photographer), you'll cherish the RAW format because it enables you to squeeze out the last ounce of quality from your pictures.

With precise exposure and an accurate white balance setting, JPEG files can provide exceptional quality–but not the flexibility of the RAW file format.

Shooting JPEGs

Do you prefer shooting JPEG photos despite the obvious advantages of shooting RAW? Sacrilege. And shame on you. And me. I confess there are times I convince myself I don't need the highest quality photos and don't want the extra effort required by processing RAW files. I get tired of their large size clogging my hard drive, no matter how much memory I have. Plus, shooting JPEG provides the challenge of getting exposure and white balance right the first time. They're unforgiving, whereas RAW files offer a type of mulligan, a chance to fix things after the shot.

At the same time, not taking advantage of RAW's mulligan-like ability can be risky. Not only do you give up the advanced capability to enhance exposure, white balance, and utilize 16-bit data, you lose the potential to improve old RAW pictures in the future when RAW adjustment software is improved.

Ahh, so what? We all need to go on holiday once in a while, and JPEG can be your photo holiday from the image processing usually required in the computer for RAW files. Only a discerning eye can detect the differences in a print made from a RAW file and one created from a high quality JPEG file. Although the camera saves JPEGs as 8-bit data files, it adjusts the recorded image data in its native 12-bit depth before creating the JPEG. Most cameras manipulate that 12-bit data to encode sharpness, exposure, white balance, and other attributes. That's similar to what you do with the unprocessed data in the RAW adjustment software. So if you take a JPEG picture with the camera set to its highest resolution and lowest JPEG compression and produce a file that needs minimal tonal and color adjustments, you are creating a high quality photo even though it's a JPEG. Of course, I'm not encouraging you to regularly shoot JPEGs, but I am acknowledging that the photo gods won't hurl thunderbolts at you for occasionally sinning.

Exposing

Correct exposure is always important, and becomes even more critical when shooting JPEG files. Overexposure results in lost highlight detail–gone will be the delicate swirls of lace on a wedding dress or the wispy strands of hair twisting free from your grandmother's braid. Underexposure sends shadow detail to the lost land of the dark–turning the furrows of a freshly plowed field or the crackled burnt pattern of a fireplace log into unsightly black blobs.

Most photographers, especially those who learned photography by shooting slide film, usually prefer to preserve highlight detail by slightly underexposing. But in digital that can make it difficult to retain shadow detail without showing excessive noise when adjusting in Photoshop. You're caught between a rock and a hard place. Your first priority would be to expose correctly for the important areas and let the others land where they may. Your second would be to understand what your options are in Photoshop adjustments. Your best option is to bracket exposures and use the histogram. You can later combine a range of exposures in Photoshop to widen the dynamic range if you kept the scene composition constant (see pages 60-61 and 104-105).

Set Maximum Quality

Your camera likely has a couple of settings that affect JPEG quality. Naturally, you want to optimize these settings. First set the highest quality-level (meaning the least amount of compression) that will be applied to the JPEG file. Quality settings are often expressed by terms like basic (good), normal (better), and fine (best). On my high-end Nikon D-SLR, the fine setting compresses images files to 1/4 of their original size, while normal compresses to 1/8, and basic to 1/16 (which it accomplishes by throwing away data). Check to see if your camera has any other adjustments or settings that may affect quality and make sure you optimize these. And finally, make sure your camera's resolution is set to the largest size.

Check Camera Settings

Unlike the RAW format, which ignores many of the internal camera settings, JPEG format delivers a final file that includes those adjustments. Your camera likely includes settings for sharpening, tonal adjustment, saturation, color balance, and white balance. If you truly want a final file that requires minimal modifying later, then go ahead and set the camera to adjust the file to your liking. Keep in mind that different subjects (a portrait as opposed to a scenic) probably require different approaches.

However, if you like to make your final adjustments using software in the computer, where you have greater control, then you should try to minimize the influence of camera settings (except for white balance, which you will want to set correctly because it will be difficult to correct during image processing in the computer) by setting them to low or neutral. Once internal camera settings are made, they are finalized into the JPEG file.

For stationary subjects, use the lowest ISO setting available (and a tripod) to maximize quality. To insure shooting with the lowest ISO, set it manually and don't rely on the AUTO ISO function.

Selecting ISO

Let's not obsess about selecting the appropriate level of sensitivity. When you don't need an action-stopping shutter speed, use the lowest ISO on your camera to minimize noise. Make sure you haven't chosen a setting that lets the camera automatically adjust the ISO, because it may choose a setting that is higher than you actually need. Don't fret making these decisions, even if you photograph moving subjects (be they people or animals), or when you work in dim light where the effects of noise from long exposure may be worse than those from increased ISO. Just use the lowest ISO when other demands aren't stronger.

The Photoshop histogram (illustrated below) for this photo shows a spike of dark tones and a larger distribution of mid tones, as well as a small bit of clipping in the brightest whites in the surf. In this case, the slight overexposure was desired for creative effect.

Exposure: The Cornerstone of Image Quality

Just maybe the most important development of digital photography has been the histogram. Until its arrival, photography, even with exposure meters, left you in the dark about knowing if you had truly succeeded in taking a well-exposed picture until you saw your developed film. Before the histogram, taking a picture was a bit like hitting a blind golf shot to a green that's over a hill and nestled in a wooded nook. Thwack–it feels and looks like the perfect shot, but until you run to the crest of the hill you won't know. Now, with the histogram, you can know instantly.

Note: One of the few problems with the camera histogram is that often it's quite small. It may be difficult to see tonal distribution in a histogram less than an inch (2.54 cm) high.

Achieving correct exposure is the result of using the meter and the histogram. The meter tells you what to do. The histogram tells you whether you succeeded. And if you're an experienced photographer, you might be able to take pictures like Edward Weston without even using a meter–because the histogram will let you evaluate the exposure of the picture.

What's all this about exposure? Why is it so important? Because you need to properly expose the scene in order to achieve full dynamic range of the sensor and capture continuous subtle tones, colors, and details from shadows to highlights. It's that simple. If your exposure is off, your quality is off. Maybe just a nick off, maybe even unnoticeable (and maybe not), but still it's off.

First you must meter the scene accurately to correctly expose it. To do this, you need to determine and meter both the darkest area that should show shadow detail and the lightest area that should show highlight detail. And you need to confirm that exposure with the histogram, preferably with your camera's highlight clipping feature (if it has one) turned on, which blinks in areas of the picture where highlights were overexposed. If I were a cynic (and I am) or if I were excessively practical (and I am), I would tell you to forget what I just said about metering and simply take a few test pictures, looking at the histogram to determine if you're getting the right exposure. Because in the end, you evaluate the histogram and confirm that your exposure is maximizing the dynamic range. Hooray for the histogram. It is our exposure savior.

However, despite the value of the histogram, you should still meter the shadows and highlights to determine the exposure for each, as well as the dynamic range for the scene. If the dynamic range exceeds six stops, you probably won't be able to capture it all in a single exposure, or you will have to compromise and sacrifice highlight or shadow detail.

Determining Dynamic Range

Set your camera to the Aperture-Priority mode and the lens opening to f/2.8 or f/4. Find the darkest area of the scene in which you want to show some detail, take a meter reading from it and note the shutter speed–let's say 1/30 second. Now find the brightest area of the scene in which you want to show some detail. Take a meter reading from it and note the shutter speed–let's say 1/2000 second. To find the dynamic range in full stops, count the number of shutter-speed intervals from the first reading to the lasting reading. That will be the dynamic range.

Stops	0	1	2	3	4	5	6
Shutter Speed	1/30	1/60	1/125	1/250	1/500	1/1000	1/2000

Since that picture is six stops, you can probably use one exposure to capture the full dynamic range. But how do you determine that exposure?

Determining Exposure

Again, hooray for the histogram. It will absolve writers who don't clearly explain how to determine exposure and photographers who never carried an incident meter or learned how to effectively use their camera's built-in meter. In fact, I'm going to play heretic and tell you to expose by the histogram. You'll be judging exposure by the histogram anyhow, so why waste time carefully evaluating the scene for exposure. Keep in mind, determining exposure by histogram is only effective when you photograph immobile subjects that allow enough time to figure out the best exposure by shooting and reshooting the scene. Simply take the picture and see what the histogram reveals. If you understand the histogram, and have an inkling of scene reflectance, you can create a good exposure.

To evaluate exposure using the histogram:

1. Set the aperture to achieve the depth of field you want. Or, if you think shutter speed should take priority, set the shutter speed you want.

2. Let your camera's built-in meter set exposure, then take a picture.

3. Look at the histogram. If it's too far to the left, you need to increase exposure (larger aperture or slower shutter speed). If it's too far to the right, you need to decrease exposure (smaller aperture or faster shutter speed).

4. To change the exposure, use the exposure compensation dial (or by changing the aperture or shutter speed if you've set the camera to Manual mode).

5. Repeat steps 3 and 4 until you achieve a histogram displaying the full range of tonal values without any clipping.

6. You may want to increase exposure by 1/2 stop and take a second picture so the brightest highlights are slightly clipped (overexposed). You can recover them with Camera Raw. With digital cameras, you should slightly overexpose to maximize the tonal scale.

Slide-film shooters and adherents to the black-and-white zone system had to know how to meter (or bracket a lot) to get a good exposure. Back in the 20th century there were no histograms to confirm that exposure was good.

Even though you can select from several sophisticated metering methods with a D-SLR, Its still a good idea to review the camera's histogram to make sure your exposure is good.

Exposure is the amount of light the camera delivers to the sensor to create a picture of the proper brightness. The camera uses the size of the lens opening (aperture) and duration of the shutter speed to control that amount of light. To measure the amount of light in a scene, the camera uses a built-in exposure meter. This meter sees the world as midtone objects, things that reflect an average amount of light. Midtones are middle grays. Green grass is a midtone, and so are faded Levi's. A meter wants to make everything into midtones. If it sees a sunlit field of snow, it thinks midtones. If it sees freshly laid asphalt, it thinks midtones, even though neither of these scenes is gray.

But today's cameras are smart (used to be the photographer had to be smart) and use advanced exposing systems to compensate for the middle gray leanings of the exposure meter. Multi-segment (also known as matrix or honeycomb, etc.) metering is an

intelligent exposing system. It uses a computer program to evaluate the brightness coming from many segments of the scene–the dark parts, the bright parts, the "important" parts, and so on, in an attempt to give good exposure. Its program includes hundreds, if not thousands, of likely scene reflectances and compares the scene you are photographing to those in its memory, adjusting exposure accordingly. This type of metering works pretty darn good. But you can't use it to determine the exposures required for the shadow and highlight areas because it will try to outsmart you. For those areas you will want to use your camera's spot or averaging (often referred to as center-weighted) meter.

That's easy enough. Here's how.

1. Set the camera to Aperture or Shutter Priority mode and select the aperture or shutter speed you want to use.

2. Set the metering mode to spot if you need to determine exposure of a small subject in the distance. Set it to center-weighted averaging if you can walk up to the subject and take a close-up meter reading.

3. Take a meter reading of the brightest area you want to show detail. Note the recommended setting.

4. Take a meter reading of the darkest area you want to show detail. Note the recommended setting.

5. Determine the dynamic range by counting the full stop intervals between the two readings. (See pages 60-61 about HDR technique for use where range is 9+ stops).

6. Use the accompanying table to decide how to set the exposure for the dynamic range of your scene.

7. Take the picture and check the histogram to verify a good exposure.

Exposure by Dynamic Range

Dynamic Range In Stops	Exposure Technique	Set the Exposure	Comments
3-4	Single correct exposure.	Set the exposure 1/2 stop more than the midway point.	Slight (1/2 stop) overexposure will extend shadow tonal range.
5-6	Single exposure; but bracket +1 just in case.	Set the exposure 1/2 stop more than the midway point.	1/2 – 1 stop overexposure will extend shadow tonal range.
7-8	2-3 exposures: one for shadows, one for highlights. Combine in Photoshop.	Take one picture at the shadow meter reading, another at the midtone, and a third at the highlight reading.	If 2 exposures not practical, slightly overexpose by 1/2 – 1 stop.
9+	3 or more exposures varied by 1 stop and combine using HDR technique.	Take a picture at the shadow reading, and then take a sequence increasing exposure by 1 stop until you reach highlight meter reading. Combine using HDR function.	If not practical to take multiple exposures, determine subject area that needs best detail and expose for it.

The top picture is a high-contrast scene with less than optimal exposure of bright and dark areas. The high dynamic range (HDR) technique (used below) reveals the wide tonal range without loss of detail in the highlights or shadows.

HDR: The Darling of Ultimate Quality Enthusiasts

Since precise exposure is critical to maximizing the amount of data captured for later enhancements, the quality photographer not only shoots using RAW format, but regularly brackets exposures in 1/2-stop increments over a -1 to + 1-stop exposure range. And having an exposure bracket of three stops over three shots also means you can use the high dynamic range (HDR) technique to extend the tonal values of your picture.

High dynamic range imaging has developed an enthusiastic following among photographers. It is a multi-exposure, multi-image merging technique that is capable of holding the full dynamic range of a high-contrast scene and is therefore a method for overcoming the limited dynamic range of imaging sensors. The sensors in D-SLRs simply can't stretch their pixel arms wide enough to embrace the full range of tones in

high-contrast scenes. Think of brilliant sunlight polishing a whitewashed house on a Greek Island with the door open to a pottery display in the dim interior. The tonal range could easily reach 9 or more stops–well beyond the five or six-stop range of the typical sensor.

Enter HDR. Using a constant aperture, you determine the shutter speed required for the exposure extremes: The correct exposure to hold detail in the highlights and the correct exposure to reveal fine points in the shadows. Then mount the camera on a tripod, set the focus and aperture, and take a series of bracketed exposures until you cover the full range–and maybe go a stop beyond each extreme just to be sure.

Static scenes are perfect for the HDR technique, because moving subjects (waves crashing, sailboats sailing, clouds scudding) won't register properly in the three or more shots combined using HDR. If forced to take only a single shot in high-contrast lighting, you must decide what part of the scene needs to be correctly exposed and then properly meter it. Most cameras provide spot metering that lets you determine how to expose specific small areas. You can also use the spot meter to measure the darkest area and the brightest area to determine the tonal range confronting you, and then decide if a compromise exposure will fit your needs.

Many photographers optimize exposure for the highlights. Losing detail in dark areas is usually less objectionable than bright areas because lost highlight detail from overexposure can ruin a picture. Consider what it looks like when the highlights in breaking surf, flowing dresses, or canopies of cherry blossoms are completely blown with no detail: Not a pretty picture! The general rule for digital photographers using RAW format is to slightly overexpose, up to ½ stop, and then adjust the highlights when opening the RAW file. Slight overexposure has the added benefit of opening the shadows.

Once you have recorded the series of photos for HDR use, you will need to finish the process with image-processing software in the computer. Photoshop CS contains a HDR function (File>Automate>Merge to HDR) that combines these exposures to create one image that reveals full image tonality and detail–from brilliant highlights to dark shadows.

Step-by-Step HDR Procedure

To successfully create an HDR image, you must adhere to some specific techniques because you are making several exposures and later registering the images. Any changes other than shutter speed could ruin your efforts. You can shoot in JPEG or RAW mode.

1. Set the camera to Manual exposure mode.

2. Set the ISO. Do not use the auto ISO setting as it could change the ISO value during the exposure series.

3. Set the aperture based on the depth-of-field requirements of the scene.

4. Meter the darkest and brightest areas of the scene to determine the maximum and minimum shutter speeds you'll need to expose them correctly.

5. Determine how many exposures you need and the corresponding shutter speeds to take you through the exposure series. Although you could use an auto bracket function, I suggest manually changing the shutter speed until you become comfortable with the process. You can vary shutter speeds in ½- or 1-stop increments.

6. Mount your camera on a tripod, compose the scene, and then lock the camera down tight.

7. Focus the camera and don't change the focus during the exposure series.

Focusing

Accurate focus is critical to revealing the superior quality of the lens you selected; even the best image-processing software doesn't really let you overcome a picture that is out of focus. Your camera has a variety of autofocus modes. Several of these, such as continuous, predictive, and trap focus, are intended for various forms of action photography. Your camera may also feature automatic area focus modes that evaluate the scene and decide where to focus using built-in criteria of subject position and nearness to the camera–great for party shooting, but usually not so great for the quality photographer. Action focus modes are valuable features that react much faster than you can manually focus, and action photographers need to consider speed of focus. Learn about these focus modes for your action photography and use them appropriately.

For critical focus, I often wrest focus control from the camera. Since most of my subjects don't rapidly move, I use either manual focus or single-area autofocus with focus lock. I use these two modes because I know exactly where the camera is focusing and when it's in focus. That's especially important when I am isolating a subject with selective focus, but it's also helpful in maximizing depth of field. Because the selective focus technique typically involves focusing a telephoto lens set to a large aperture on a subject within a few feet or less, the depth of field may range from an inch to a foot (2.54 to 30.48 cm). In close-up nature photography, depth of field may be a matter of millimeters. That leaves little room for error, meaning you must not only focus precisely, but also know what to focus precisely on. For example, it's long been a given that the eyes in portraits should be sharp (although some creative types have been known to go for the nose, the lips, or even an ear).

The point is to focus on an important area that can reveal sharpness by contrasting its distinct detail against the blur of out-of-focus areas. And how do you achieve such critical focus? Though the convenience of autofocus cannot be denied, make sure you lock it if you use it. Even so, I often adjust the camera on a tripod to lock autofocus on a specific portion of the subject, and then move the camera slightly, recomposing to take the picture. No big deal when using an aperture of f/11, but with the shallow depth of field of critical selective focus, that small camera movement can be enough to change focused distance, bringing the focused area out of the extremely shallow depth of field. The result could be a slightly soft image. Of course, many cameras also let you select a single focus point in the viewfinder, allowing you to overlay it on the critical subject area so you don't have to lock focus and recompose. But I find that technique more difficult than simply manually focusing.

Effective Camera Position

Camera position determines scene perspective and lighting angle. Naturally this has an impact on the creative quality of your picture. So for creative reasons, you should choose camera position carefully, following the guideline that if it looks good, it is good–for you.

In close-up photography, positioning the camera to align its focus plane to the primary plane of the subject increases the sharpness in a subject with minimal depth of field. To do this, simply align the back of the camera to be parallel with the critical subject area. If you're photographing a leaf, the back of the camera would be parallel to the plane of the leaf. Of course, this may not yield an appealing composition, but use it when you want to maximize the area of sharpness.

When photographing small buildings (one to three stories high), place the camera at a level about halfway up the height of the building (if your surroundings allow) in order to minimize perspective distortion. If such high ground isn't available, you may be able to minimize distortion by using a wide-angle lens and pointing the

camera slightly downward to position the building at the top of the viewfinder so its vertical lines are parallel to those of the camera frame. The downside is that the bottom of the picture becomes wasted area that you'll likely need to crop, thereby lowering resolution and reducing enlargement potential.

In portraiture, camera position and lens choice combined with pose can dramatically alter the appearance of the subject. Camera position can enlarge or minimize, emphasize or subordinate, hide or showcase facial features, including the nose, chin, eyes, forehead, and hairline. Although these deserve great consideration, they fall more into the category of aesthetic rather than technical improvements.

The most dramatic technical impact from camera position comes when you determine the angle of light in your scene, especially when shooting outdoors. The angle of light influences exposure and apparent sharpness. For instance, if you choose sidelighting, you may be faced with dark dominant shadows that force you to either use the bracketed-exposure HDR techniques or to overexpose somewhat to reveal shadow detail. On the other hand, such high contrast of shadow and light emphasizes apparent sharpness, giving your picture a sense of being razor sharp, an effect diminished by frontlighting or diffuse lighting. If you choose backlighting (facing the camera into the sun), you risk severe flare (unwanted streaks or rings of light). Most often you choose light for its creative effect, so let's not dwell unnecessarily on its impact. Just keep in mind that where you position the camera determines the direction of light and requires different approaches to exposure and sharpness.

Great camera position and timing create an effective geometric composition of light, shadow, and subject. Photo © Gary Whelpley

The close camera placement emphasizes the saddle over the rest of the elements in this photo, with the soft background reinforcing the subject.

In some scenes, careful camera placement can highlight (or hide) the subject. This can be both an aesthetic and technical decision. Its impact is most dramatic in close-up work, where even a slight shift of an inch can change the feel of a picture. In addition, most photographers know they should look out for the "background bomb," that annoying object behind your subject (telephone pole rising from a head) that may be overlooked while concentrating on taking a picture but which becomes obvious when the picture is enlarged (and may require substantial retouching). Always position the camera so subject and background complement each other. Better yet, position the camera (or subject) so the background or surroundings optimize the subject and reinforce your intent.

I often change camera position to find an angle that highlights the subject by contrast. Portrait photographers use a background spotlight to do this. Outdoors, you may be able to find a bright background for a dark subject, or dark background for a sunlit subject. This contrast emphasizes the subject and exaggerates apparent sharpness.

Lighting

Two primary technical concerns arise when dealing with lighting: (1) manipulating the impression of sharpness that you desire, and (2) creating a manageable tonal range. High-contrast lighting emphasizes apparent sharpness, but its abundance of highlights and shadows (wide dynamic range) makes if difficult to capture all of the details. On an overcast day, the dynamic range for a wheat field with a barn may only be 3 or 4 stops. On a sunny day, however, the dynamic range of that same scene is more likely to be 5-7 stops (see exposure methods, page 59).

Outdoor photographers can manage light to a certain extent by using flash and reflectors to fill foreground shadow area, but otherwise they must wait for the right lighting to appear, change their position to achieve an improved angle, or bracket exposures and use the high dynamic range technique. In the studio, where more aspects of lighting can be controlled, photographers should act as if they are shooting transparency film and set up the lighting for a five or six-stop range, using fill lights to lighten shadow areas with important detail and gobos (light blockers) to darken highlights with important detail.

White Balance

Since the RAW file format allows you to adjust white balance after taking the picture, do you really need to consider the white balance setting when using RAW to record your images? Probably not, but first consider a few points. Are you shooting just RAW or RAW + JPEG? If you are including a JPEG file, its white balance will be whatever you have set on the camera. You can probably set the white balance to auto and be quite happy with the ensuing JPEG, but you'll get more consistent results if you follow a quality procedure and set the white balance to match the present lighting conditions. You may even want to place a white card in the scene for one shot to use later for color balancing.

Better yet, create a custom white balance setting specifically for the scene you are photographing whenever it's important to record accurate color. For our discussion, accurate color is how you expect colors to appear under the midday summer sun, called white light because all the red, green, and blue color components are present in equal amounts (creating white light). In terms of color temperature, such lighting is around 5500 Kelvin (though some folks use 5000K as the standard white light).

By using the Custom white balance setting, you can precisely measure the lighting conditions in the scene, ensuring the most accurate color possible.

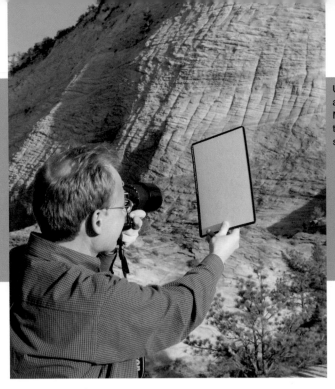

Use a white or gray card to take a Custom white balance reading. Make sure the card is placed so that the light is the same as that striking the subject.

Color Mode

There are many reasons to wholly or partially preserve the color balance of the scene lighting. For instance, the weak light of midday in winter reinforces the stark mood of the sun's low slanting rays. The burnt orange light of a setting sun bathing rocking chairs on a seaside porch speaks powerfully about the end of the day. But when you decide you want the colors to be accurate, as they would appear under neutral white light, use the custom white balance. However, be aware there is always the risk that the available lighting will be missing large amounts of certain colors, so the normal color proportions of midday light aren't there. For example, the light of sunset has less blue and green because it travels through more atmosphere (than at midday) that filters out those wavelengths. Even though you use a custom setting to "effect" white light, you likely won't recreate those normal proportions. Thus, the whites may be neutralized but the other colors, the whole scene in fact, could look a bit off.

To begin the custom white balance procedure, pull out your white balance tool–be it a gray card, a white card, or an expodisc–and position it to receive the same lighting as your subject. Focus on the white-balancing tool and press the shutter button. Follow your camera's instruction manual to make sure you have adjusted the white balance setting correctly. You can use that white balance setting as long as the lighting remains similar. Through trial and error, or by placing a white card in the scene, you could likely achieve a very similar effect through Camera Raw Software, but why not do it right up front.

Most cameras offer a selection between two color modes: sRGB and Adobe RGB (1998). I recommend Adobe RGB (1998) because it offers the potential for higher quality files with a wider range (gamut) of discrete colors. The sRGB color space was originally created for displaying pictures on monitors and for use on the Internet, so its color gamut is smaller than that of Adobe RGB (1998). One advantage sRGB offers is that most printing devices, especially those at online photo printing services, are set to use sRGB files. So the general computer world works well with sRGB files. At the same time, advanced printing equipment and labs usually can handle the more sophisticated space of Adobe RGB (1998).

There are additional color spaces, like ProPhoto RGB, that offer the potential to reproduce many more colors and to withstand more image manipulation than others. These result in a final image with greater color range. With JPEG files, the color space you choose in the camera is usually applied to the file. However, if you shoot RAW files, setting the color mode in the camera won't make a difference because you can select another color space during processing in the computer using RAW software.

You can minimize cropping and utilize the full capacity of your sensor's resolution by taking several different compositions of the same subject. Review these later to determine which works best.

Compositional Bracketing

Quality photographers count pixels like Silas Marner counted gold coins. In fact, most of us stretch our pocketbooks to get the highest megapixel camera we can afford. So don't throw away your money through careless composition that later requires substantial cropping. Cropping 20 percent of the picture in effect turns a 10-megapixel (MP) camera into a 6MP camera, and a 16MP camera into a 10MP camera. Not exactly what you paid for. Though it is true you can still make a high-quality enlargement by cropping 20 percent from a 16MP sensor, it's better to crop in-camera so you can keep all 16,000,000 pixels and make a larger high-quality enlargement, such as a 16 x 20 inch (40.6 x 50.8 cm) print.

Cropping later effectively magnifies the image. That means you magnify its flaws and put a greater strain on any existing limitations of focus, depth of field, sharpness, and noise. You can reduce cropping by practicing compositional bracketing when you take pictures. You may find a scene offering several compositions. You won't know for sure which you like best until you review each one on the computer. The key to preserving resolution with compositional bracketing is to compose a couple of shots very tightly, so they literally can't be cropped on the computer without destroying the composition. Then widen the composition, including extra space for cropping if the tight composition doesn't work.

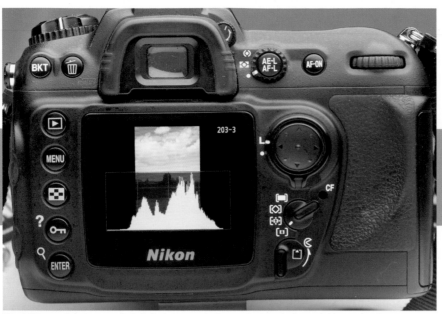

The LCD monitor is one of digital photography's greatest tools for quickly evaluating your photos. If you don't like the results, you can reshoot while still at the scene.

Using the LCD Monitor for Quality Assessment

The LCD offers two important functions to evaluate pictures: (1) a display that can be magnified to analyze sharpness, and (2) a histogram to evaluate exposure.

Note: Don't use the visual display of a picture on the camera LCD to evaluate exposure because appearance varies greatly with the environmental lighting and the brightness setting of the LCD. Check to see if your camera has a highlight indicator that causes overexposed highlights to flash when the image displays on the LCD.

Your camera's histogram is a tool that is critical for achieving quality images and should be used to analyze the exposure of your pictures. It gives a good idea if your photo is under or overexposed by displaying tonal values for a JPEG file (even if you are shooting only RAW, which means you may have more leeway to hold highlight detail with a RAW file than the histogram indicates). Some cameras even give the option to display three histograms simultaneously, representing the individual RGB values: one for red, one for green, and one for blue.

Even after years of using in-camera histograms, I am sometimes surprised by how dark or bright a picture looks even though I thought the histogram was fine. So to insure the photo looks the way I want it to, I continue to bracket exposures to be sure I have a good one.

My D-SLR lets me enlarge the image 25x. The problem is that the resolution of the LCD and its physically small size make it difficult to accurately judge sharpness over the entire image. I can see if an image is badly blurred, and I can detect if specific areas are sharp or not, but its difficult to form an overall impression of picture sharpness. You might want to consider carrying a laptop. The LCD does, however, excel for composition.

You can take a laptop with you to virtually any photo destination in the world if you choose.

A Computer in the Field?

Essentially digital photography is computer-processed photography. A computer with Photoshop or some other image-processing program forms the basis of your digital lab at home. So why not expand these near supernatural powers by lugging a laptop computer to your photo shoots–be they at the base of a waterfall, at a wedding inside a cathedral, or at the local museum? That's actually a fine idea if you're willing to shoulder another eight pounds (laptop plus carrying case).

With a laptop on hand, you can open the image and effectively assess it both technically and aesthetically. Sharpness, depth of field, exposure, dynamic range–all can be evaluated using a laptop. You can even connect the camera to the computer so that when you take a picture it instantly appears on the laptop.

However, I must admit that I don't often carry my laptop in the field. That's a personal choice since I fancy myself an outdoor photographer. The joy of photogra-

phy for me is watching a waterfall leap from a cliff or spotting a bloodroot blossom peeking out from a rock. Carrying the laptop diminishes that experience, so I leave it at home, or in the car if I'm on a road trip. Then at night I can download images, evaluate them, and back them up. Yet for the quality photographer, reviewing images frequently on a laptop can enhance the technical quality of their photos. Decide for yourself whether a laptop gives you quick feedback that helps you learn or if it slows your picture taking and takes away from the personal pleasure of photography.

Note: When I'm at home photographing still lifes or people, I frequently stop taking pictures and check the images on my desktop computer. There's nothing like looking at your photos on a big, color-accurate monitor.

Achieving Sharp Images

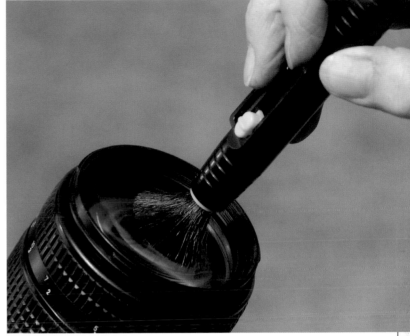

Photo © Gary Whelpley

Choosing Which Lens to Use

Ultimate image quality is closely tied to lens selection. You should always use your best lens for the photographic task at hand. Of course that's obvious, but how often do we actually do the obvious things in life, like give up doughnuts for broccoli, trade coffee for carrot juice, or go for a run instead of watching TV? In the age of zoom lenses and automatic settings, the temptation of convenience abounds. Which of us doesn't have an all-purpose wide-angle-to-telephoto zoom, and which of us hasn't succumbed to using it even though we know better quality resides in another lens? Resist the lure of wide-range zooms. In striving for the utmost in quality, the best single-focal length lenses still squeak by the best zoom lenses. So if you have a high quality single focal-length lens, use it whenever possible. If you don't, get one.

Preparing the Lens

As the doctor of ultimate image quality, you need to treat your lens with the spotlessness that a hospital treats an operating room. Cleanliness prevents dust that can make your pictures look like they have measles. In short, clean lenses (and clean sensors) give clean pictures. Before you attach the lens, look over the front and rear elements to make sure they are clean. Remove a protective filter if you have one on the lens, especially if you are aiming towards the sun. The extra glass surfaces of a filter may degrade the image, however slight that may be.

Checking the lens for dust and fingerprint smears is basic but crucial. A good friend once asked me to look at a photo of her family reunion. Over a hundred people representing four generations from around the country were in the picture. To fit them all in the picture, my friend climbed on the roof of her house and had them all look up at her. But all the faces on the right portion of the print were blurred, leaving over twenty people unrecognizable (and quite unhappy). She

had the camera with her, so I looked at it. A large fingerprint had smeared across the lens. Apparently she had left her camera on a table during festivities and a curious, greasy-fingered child had grabbed it and left a big thumbprint on the glass.

Also, shade the lens. Extraneous light striking the lens also degrades the image. This may occur subtly by lowering contrast, or obviously by creating flare in harsh direct light. You should make sure you have the proper lens shade, but if you lack one, hold a piece of dark cardboard, a hat, or even cup your hand above the front of the lens to reduce unwanted light from striking the lens.

Choosing the Aperture

From the perspective of ultimate image quality, use the aperture that gives you the greatest sharpness and minimizes cameras flaws such as vignetting, chromatic aberration, and pincushion or barrel distortion. If creative requirements don't dictate another aperture, choose the one your testing showed as being the best. Didn't do the testing? Then you should usually choose a mid-range aperture. On a wide-angle lens, that would be f/5.6 or f/8. On a normal lens, that would be f/8 or f/11. On a telephoto lens, that would be f/11 or f/16.

Perhaps more important than choosing the best aperture is not choosing a bad aperture, which usually means you should avoid using the largest or smallest aperture of the lens. On most lenses, the largest aperture, such as f/2.8, reveals the greatest number of flaws. And the smallest aperture, be it f/22 or f/32, results in diffraction, reducing sharpness. Diffraction occurs when the lens opening is so small that it interferes with the transmission of longer wavelengths through the lens.

Image-degrading flare, appearing in this photo as a series of lighter circles in the center and upper right, can often be avoided by the use of a lens hood.

Don't underestimate the effect of aperture selection on image quality. The setting of f/4 (above left) is less sharp than f/8 as shown at right.

When creative demands seem to conflict with those for technical quality, look for a reasonable compromise. What good is a lovely backlit portrait of a dew-covered, red admiral butterfly if the small aperture turns the background of cattails into an annoying fence of vertical stripes? It may be better to sacrifice some depth of field for a less distracting background–go ahead and shoot at f/5.6 rather than f/16 to create a more pleasing background.

But let's say your telephoto macro lens opens all the way to f/2.8. Should you shoot at f/2.8 when using selective focus? If your testing and analysis shows good results, of course, you should do so. But in general, evaluate the impact on your creative effects of stopping down one or two stops. You may well maintain the creative effect, in this case selective focus, while reducing the worst optical flaws.

Also consider that the area of least sharpness for most lenses is along the edges of the picture. Lens sharpness usually increases towards the center of the lens. This is

exaggerated when you choose a large lens opening. As noted elsewhere, using a large lens opening can also exaggerate chromatic distortion and vignetting. So when using a large lens opening, place areas with fine detail or high-contrast edges away from the borders of the picture.

Maximizing Depth of Field

Fifty years ago there were more tools to maximize depth of field than found on the equipment of today. Depth of field corresponds to the front-to-back distance that appears sharp in a picture. It's of critical importance for landscape photographers like myself because we often like our pictures to be sharp from the immediate foreground to the distant background, referred to as infinity in photographic terminology, and represented by the ∞ symbol on a lens' distance scale.

Zoom lenses were few and far between in those days, so we (well, not me because I was only six back then) used prime (single focal length) lenses that made it fairly simple to determine the depth of field we wanted. But that has changed with today's preponderance of zoom lenses and the use of sensors that are smaller than 35mm film frames (24 x 36 mm). What are the actual problems? Since few zoom lenses offer the engraved distance and depth-of-field scales that enable you to calculate the depth of field, you never really know what depth of field you are achieving with them. That's one of the reasons I like to carry one or two prime lenses–because most (not all) have depth-of-field scales. But even they present a problem. Unless you have a full-frame camera that uses a sensor the same size as a 35mm film frame, the scales won't be accurate. Only some high-end D-SLRs have these large sensors. Cameras with smaller sensors render the scales inaccurate on those few lenses that have them.

The solutions to overcome this depth-of-field problem may be a bit cumbersome, but they are of critical importance to the quality photographer. Users of zoom lenses need depth-of-field tables: either printed versions or software programs for your PDA. These tables are straightforward; you need only determine and set the focus distance. If you don't have a full-frame camera, you'll get more accurate results using the depth of field tables rather than using the scale on your lens.You can also find depth-of-field calculators online at www.dofmaster.com and www.bobatkins.com.

Getting away from charts and using the scales embossed on your prime lens may require a little practice if determining depth of field in this way is new to you. One key is the focal-length multiplier. You will need to use a smaller (higher number) f/stop than the scales recommend If your sensor requires this type of compensation.

While many new lenses don't have a depth-of-field scale, it is a handy tool to take advantage of if your lens offers one.
Photo © Gary Whelpley

Many D-SLRs with APS-C sized sensors require a focal-length multiplier of about 1.5x or 1.6x to approximate the field of view the lens would give if mounted on a 35mm SLR. Use an f/stop that is two stops smaller (higher number) than the scales indicate for these types of cameras. Cameras with focal-length multipliers actually offer more inherent depth of field than 35mm film cameras and those with full-frame sensors. But keep in mind that a 28mm lens on a camera with an APS-C sensor effectively acts like a 42mm lens (1.5x). That's why zoom lenses with a wide angle (16mm or wider) have become popular in recent years: They act like a 24mm lens on a 35mm camera, which is a truly wide-angle lens.

If your camera is full frame and doesn't have a focal-length multiplier, use an f/stop 1/2 to 1 stop smaller (higher number). For example, if the scales indicate f/14 use f/16. You do that because the scales aren't critical enough for quality photographers who make bigger enlargements.

Hyperfocal Distance

The traditional procedure for maximizing depth of field is to determine the hyperfocal distance and then setting the aperture accordingly. Hyperfocal distance is the distance at which you focus the camera lens to create a sharp picture that extends from half that distance to infinity. Sound confusing? It probably is if the concept is new to you. Setting focus at the hyperfocal distance allows you to pick the aperture that will sharply show the nearest subject you want and the farthest possible subject, which by definition, if not by practice, is at infinity. That's a good procedure and one you should know.

Here's how it works. You need a lens with a depth-of-field scale and a distance scale. Let's assume you're at the scene and want to show everything sharp from a nearby log to infinity. You need to find the distance to that nearby log. Once you know that, you can determine where to focus to maximize depth of field along with the corresponding f/stop to set.

1. Set your lens to manual focus and focus on the nearby log.

2. Look at the distance scale to determine how far away the log is. Let's say it's 15 feet (4.6 meters).

3. Turn the focusing collar until the 15 ft mark and the infinity symbol are bounded by a set of aperture index marks on the depth of field scale.

4. Look at the aperture scale to see which f/stop corresponds to the index marks.

5. Now reset the aperture to compensate for the focal-length multiplier of your camera. For cameras with a multiplier of approximately 1.5x, set an aperture two stops smaller (higher f/number) than that determined in step 4. For instance, if the indicated aperture was f/8, set it to f/16—for cameras with 1.3x multiplier, set an aperture one stop smaller (higher f/number) than that determined in step 4. Avoid using the smallest (highest numbered) aperture on the lens as diffraction will reduce sharpness.

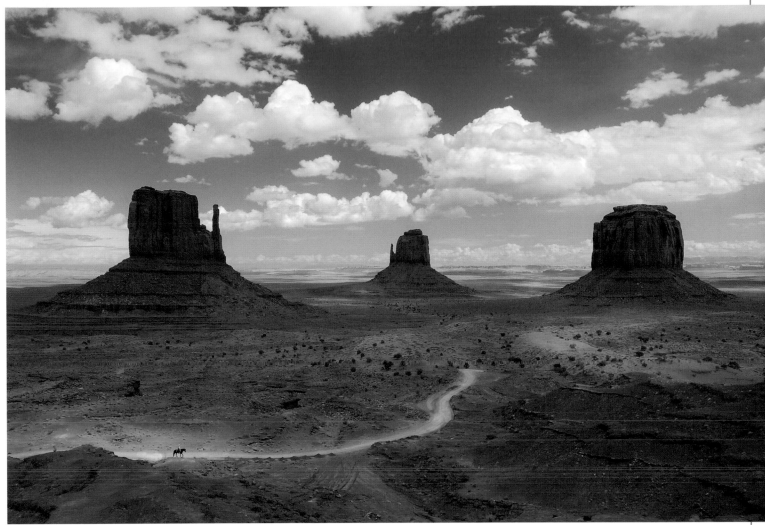

Depth of field issues are minimized when all of the elements of the composition are at a distance.

DOF Preview

If the lens on the camera doesn't let you achieve enough depth of field, your only choice is to reduce the image size as seen in your viewfinder. You can do this by moving farther away from the subject or by using a wider-angle lens. Both actions give you more depth of field (but make your subject smaller–that's the tradeoff). Although I said you have only the choice of reducing image size to increase depth of field, you do have a software option. You may be able to expand depth of field by combining two or more pictures: one in which you focused on a foreground area to maximize depth; and one in which the focus is on a mid or background area to maximize depth of field in that section of the picture. So when you combine the images with software in your computer, you combine (and extend) the depth of field as represented by the two (or more) pictures.

A number of D-SLRs have a depth-of-field button. This stops the lens down to the taking aperture so you can view the scene as it will look in the photo. Press it before releasing the shutter to evaluate whether the background will complement your picture at the aperture you selected.

Though you can make general judgments about the scene's background, don't try to critically evaluate depth of field with the DOF button. The small size of the viewfinder prevents you from actually seeing whether you have the depth-of-field sharpness you want. At small apertures, like f/16, the viewfinder is quite dark when you press the DOF button. After you take the picture, you might be able to use the magnification feature on the LCD review to roughly evaluate depth of field.

Get into the habit of properly setting up your tripod, making sure your camera is secure and all the knobs and levers are tightened to prevent unwanted camera movement. Photo © Kevin Kopp

Using A Tripod

A tripod won't stabilize your camera unless you set it up correctly. At the scene, extend and firmly lock the legs at the same length. If possible, set the legs to about 2/3 their maximum extension, using the thinnest leg sections least of all since they are less rigid. The 2/3 length is a nice compromise that provides secure support without the increased flexibility and tension on the joints that occur when the legs are fully extended, while it avoids the less stable base that results when a tripod's legs are hardly extended.

If on uneven ground, adjust the leg length or leg angle to level the tripod and establish a true center of gravity–you don't want your tripod and camera tipping over. Use the tripod's bubble level if it has one. If it lacks a bubble level, imagine you are dropping a plumb line from the center of the tripod and make adjustments until the plumb line would hang perpendicular.

Firmly attach the camera to the tripod, making sure the camera quick release plate is locked in position and that the tripod movement controls are locked so the camera doesn't accidentally swing down and tip over the tripod. If you are using a telephoto lens, use the tripod mounting collar on the lens since it will better balance the lens-camera combination on the tripod.

Now you can loosen the positioning controls to orient your camera for the shot. Take it from a clumsy photographer and follow these two rules: (1) After positioning the camera, hold onto it firmly while locking the levers/knobs on the tripod; and (2) don't trip over the tripod legs, especially if you're near water.

Note: If you have a lens or camera with image stabilization, know whether you have to turn it off when using a tripod. Many stabilization systems don't work when the camera is mounted on a tripod.

When you're done photographing, remove the camera from the tripod and return it to the camera bag. Don't be like me and sling the tripod with camera still mounted onto your shoulder because sooner or later it will fall off or you'll turn and bash it into a tree.

With telephoto lenses and moving subjects, use the fastest shutter speed possible to prevent blur. Sometimes you have to increase ISO to achieve a shutter speed that is fast enough to freeze the action. Photo © Herb Chong

Shutter Speed Is Critical

The tripod may assure image sharpness by eliminating blur due to camera movement in general photography, but super telephoto and close-up lenses require extra careful handling, even when they are mounted on a tripod. Both super telephoto and close-up lenses magnify not only the subject, but also any camera movement. Not many tripods can lock down a five-pound 1200mm lens to totally eliminate vibration-induced blur. You can usually counteract camera movement by using higher ISO settings and/or a large lens opening to achieve a fast shutter speed, but be aware of the trade-offs involved. Still, a blurred picture is worse than one with slightly increased noise from a higher ISO, so I advise you to take actions that avoid a blurred picture.

What shutter speed will counteract blur with a tripod-mounted super telephoto? That depends on the stability of your setup and is something you should test by taking a series of pictures at different shutter speed settings. But until you do the testing, let's recycle the old rule of thumb used for handholding a camera and apply it to long telephoto lenses on a tripod: That rule states that you should use a shutter speed that approximately equals the reciprocal of the lens' focal length. So with a 1200mm lens on a tripod, our applied rule would require a shutter speed of 1/1000 second to give results with superior sharpness.

If you must use your finger to release the shutter, do so smoothly and slowly to minimize blur. Photo © Gary Whelpley

Holding the Camera

Proper handholding technique is important for making sharp photos. The key is to find a comfortable and stable base with your feet that keeps you from tipping forward or backward: feet apart with knees slightly bent, and perhaps one foot a few inches in front of the other. Tuck your elbows close to your body. Grasp the camera firmly with your right hand so the bottom right corner rest against the heel of your hand and the side is pressed securely into your palm. Place your index finger on the shutter release and wrap your thumb to the camera's back. When using a long lens, cup the palm of your left hand under the lens to serve as a stabilizing shelf, with a shorter lens, tuck the bottom left corner of the camera into the base of your thumb and extent your index finger or entire hand beneath the camera. Just before taking the picture, calm yourself. Then gently and smoothly press the shutter release.

Blur created by subjects in motion is different than that resulting from camera movement. Fast-moving subjects demand fast shutter speeds for sharp, action-stopping pictures. Even slow-moving subjects when filling the picture frame require fairly fast shutters to eliminate motion blur. Of course, this assumes you're not opting for creatively blurred pictures. There are no rules of thumb here. Frame-filling subjects moving directly across your field of view are quite demanding. And those demands increase substantially as the subject moves faster or is shown bigger. Fortunately, most D-SLRs have top shutter speeds above 1/2000 second. So if the lighting allows, set a shutter speed of 1/2000 (or higher) when photographing subjects moving faster than 30 mph. Again, raising the ISO and reducing the f/stop may require trade-offs required in order to obtain such a fast shutter speed.

Similar rules apply in nature photography when photographing hummingbirds, dragonflies, hawks, cheetahs, and other fast-moving animals. In close-up work, you may have the luxury of using action-stopping flash. A more notorious type of motion that can ruin close-up photos is the wind. Notorious because the least sway of a flower in a gentle breeze may escape your notice when composing your image, but even the slightest movement can cause blur at shutter speeds of 1/30 second or longer. The tripod may eliminate blur from camera movement, but not the wind.

The Art of Releasing the Shutter

Notice the headline above doesn't say "pressing" the shutter button. There may be no more destructive act in photography than that of pressing the shutter button with your finger. It doesn't have to be that way, but too often we jab the shutter button and jar the camera, which blurs the picture–even if the camera is on a tripod.

It is much better to release the shutter with an alternative means that minimizes camera shake, such as an electronic cable release, a remote control, or the self-timer. I typically use the self-timer set for five seconds. That's long enough for the camera to settle down after I press the shutter button, which initiates the self-timer. Of course, if your subject is moving, using the self-timer may be self-defeating. Knowing there are times when you must actually (dare I say it?) press the shutter button with your finger, you should practice doing so gently and smoothly so you don't jar the camera.

In addition to its use for self-portraits, a self-timer is an effective way of releasing the shutter without jarring the camera.

Although these methods may eliminate the blur caused by a jabbing finger, they don't minimize blur caused by mirror shake. The hallmark of a D-SLR is the mirror-prism system that gives you a live and direct optical view of the scene delivered by light passing through the lens. When you take a picture, the mirror flips out of the way so the light through the lens can reach the sensor. As the mirror flips up, it hits the prism box and slightly shakes the camera, sometimes enough to blur the picture. This is most pronounced at slow shutter speeds around 1/4 to 1/15 second, because the duration of the shake lasts a similar time. At a 1-second exposure, if the mirror-induced shaking lasts 1/8 second, then it slightly shakes the image being focused on the sensor for only 1/8 the total exposure time; the other

7/8 of the exposure is unaffected, thus giving nearly sharp results. Faster shutter speeds, such as 1/60 or 1/125 second offset this slight shake.

This type of blur is subtle and can be easily overcome by setting your camera's shutter to delay opening for a split second after the mirror rises. Many cameras include a setting for the mirror delay function in the menu. I recommend using it particularly for shutter settings from 1/4 –1/30 second. The only caveat is the need to turn it off when done, otherwise you may be surprised the next time you use your camera to discover that the birthday boy has already huffed and puffed the candles into oblivion before your shutter opened to take the picture.

Even the ultimate picture is rarely perfect directly from the camera. Equipment has shortcomings, nature needs to be tidied up, and you have a vision for your photo that can only be achieved by using software to enhance the image.

Adjusting Raw Images

An image-processing program is a critical link in the chain of ultimate image quality. You need software to view your RAW file, to make adjustments to it, and to further refine those adjustments. As you go through this process, you may use two different software programs—one for adjusting the RAW file, another for refining that adjustment. Since your camera likely came with the software from the manufacturer for handling RAW files, you may prefer to use that software.

Although other companies manufacture good software products for image adjustment, there's no question that Adobe has become the leading producer of such programs, so we'll focus on several key image-processing techniques using their offerings to perfect your image file. Adobe has developed a full line of products that enables photographers of all skill-levels to manage their image workflow from start to finish. Adobe® Bridge, Adobe Photoshop Lightroom, Photoshop Camera Raw (commonly known as Adobe Camera Raw, or ACR), and Adobe Photoshop CS3: together they enable you to manage nearly every imaging task that might confront a serious photographer. And they're integrated to work together (and with other Adobe software), saving you time and hassle. Adobe Photoshop Elements is a simpler, less expensive standalone program that meets the needs of most amateurs and many pros, including the processing of RAW files and the use of layers for non-destructive editing. Elements is a good starting point if you aren't yet a user of Photoshop CS.

Note: Lightroom™ emphasizes image management and selection for photographers who take dozens if not hundreds of shots during a photo shoot. It also provides Photoshop Camera Raw for adjusting photos taken in RAW file formats. It's a useful product, but Photoshop CS or another image-processing program (many offered by companies not named Adobe) is still necessary for photographers who plan on making complex adjustments to their image files.

The most important stage may be adjustment of the RAW file. There are a number of products for this purpose, including software from your camera manufacturer and third party developers. See the next page for examples. Similarly, a whole industry has flourished that develops plug-ins for sharpening, adjusting color and tonal range, and fixing a variety of flaws. But we'll focus on Photoshop Camera Raw as provided in Adobe Photoshop CS3 (and higher). In previous versions of Photoshop CS and Elements, Camera Raw's functions are similar but less fully developed.

Feel free to explore several different image-processing software programs. Proprietary to camera manufacturers, RAW file formats incorporate an intricate structure that, like the secret formulas of Coca-Cola, are well-guarded industrial secrets. Logic would indicate that camera manufacturers know the strengths and weaknesses of their own RAW files better than anyone else, so their own software should be best at acquiring those files. However, Adobe has been at the image-adjustment game longer than anybody else, and they have developed undeniable expertise, experience, and resources.

Developing RAW Files

Text and Photos by Steve Hoffmann

From cameras to lenses to printers, digital photography offers a variety of choices. These options include the choice of software used to process your RAW files. Any digital camera that records RAW files will come with a CD that contains a RAW file conversion application. But many other companies wanting to tap into this lucrative market also offer software. Foremost and most obvious is Adobe. But they are not alone.

A basic RAW converter application consists of an image thumbnail browser and basic adjustment tools for "developing" the RAW file into a standard image file format (JPEG or TIFF, for example). New digital photographers may often begin experimenting with RAW images by using their camera company's software. However, many soon find that the aftermarket products offer more choices and fit their personal workflow style quite well. It may be worthwhile to download trial versions of these after-market RAW converters and try them.

- **Photoshop Camera RAW from Adobe**
As described in the text, this engine is supplied in Photoshop CS3 and in Adobe's Lightroom. It is vastly improved over Adobe's previous RAW conversion engine. Photoshop is an extremely robust image-processing program, and Lightroom has the capability to take a RAW image to its final output destination as a PDF or Flash slideshow for presentation or a pre-formatted html web gallery. Lightroom also supports color managed print output. The user interface of this application is excellent and intuitive.

- **Bibble Pro from Bibble Labs**
This has just about every advanced image-processing tool available. Bibble's tool set also has some plug-ins, including Noise Ninja, a professional quality noise reduction application. It also contains Perfectly Clear, which is a one-step image optimizer. Bibble has a clone and healing tool. Bibble's interface is appropriate for novice to advanced enthusiasts.

- **Capture One Pro from Phase One**
Professional photographers may want to consider this application, which can output up to three file formats in one conversion operation. Capture One Pro can also do linear conversions, useful when there is a large dynamic range within the image. This program allows the use of aftermarket camera profiles and it has a profile editor so you can tweak your own or existing profiles. Appropriate for novice to advanced.

- **SilverFast DC Pro from LaserSoft Imaging**
Prepress professionals and publishers should have a close look at this RAW converter based on SilverFast's industry-leading aftermarket scanner control software. It has a full set of RGB adjustment tools and advanced tools that particularly lend themselves to CMYK output. Appropriate for novice to advanced.

- **SilkyPix Developer Studio from Ichikawa Soft Laboratory**
This has a toolset and user interface that is easy to learn, with adjustment presets as well as sliders for fine tuning image parameters. Silkypix makes very nice conversions with default settings, and the preset adjustment approach is great for beginners. Silkypix's toolbox is full-featured enough to satisfy advanced image editing enthusiasts, too.

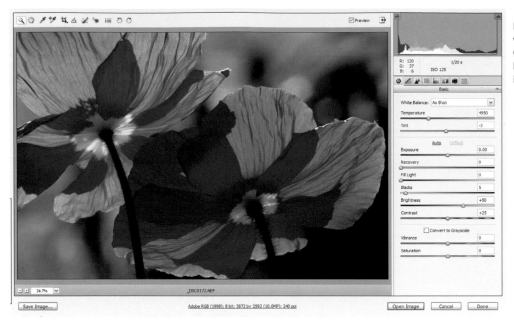

Examine the main window of Photoshop Camera Raw to become familiar with its functions.

Workflow for Adjusting RAW Images

You can work on the RAW file using Camera Raw, which is built into Lightroom, Adobe Photoshop CS2 (and higher), and Adobe Photoshop Elements. The steps below show an overview of the sequence, or workflow, to follow for best results when adjusting RAW images. These give you a general idea of what lies ahead. We'll get into more detail later in the chapter.

1. Open the RAW file from your Adobe image-processing program.

2. Crop and straighten the image.

3. Set white balance to achieve correct neutral tones.

4. Adjust the overall tonal range using slider tools. Utilize the clipping preview to show highlight and shadow problems. Move the appropriate sliders to recover burned-out highlights and to reveal detail in shadows.

5. Moderately adjust the contrast using the Contrast slider or Curves adjustment. It is better for the contrast to be slightly flat at this stage and to refine it in Photoshop

6. Correct chromatic aberration or vignetting that may have been introduced by your camera lens.

7. Lightly reduce noise in the RAW file–don't sharpen at this stage!

8. Open the file in Photoshop.

9. Continue to make adjustments by fine-tuning color, tonal range (brightness), and contrast using Levels or Curves Adjustment Layers.

10. Use selection tools and locally adjust color and tonality for specific subject emphasis.

11. Retouch the photo as needed.

12. Resize and sharpen the photo.

Note: Throughout this chapter, depending on which program you are using and which version of Camera Raw you have, some tools or options may not be present. But these instructions and procedures will still be generally effective.

Setting Up Photoshop CS and Photoshop Elements

Before you begin adjusting images, set up Photoshop CS or Photoshop Elements so they meet your personal preferences and are optimized to process your image files.

Editing and Adjusting

1. In the program, click on the Eyedropper in the tool bar. On the top menu bar, set the Sample Size to 3 by 3 in the drop-down menu. This will give a reliable sample when you use this tool.

2. Set RGB values in Levels and Curves (not available in Elements) for the Black, Gray, and White Eyedroppers so they show a slight amount of detail at the extremes of the tonal range. Note that the values mentioned are not magical and you may want to alter them for some images.

Press Cmd-L (for Macs) or Ctrl-L (for PCs) to display the Levels function. Double-click on the Black Eyedropper and enter 10 in the R (red) field, 10 in the G (green) field, and 10 in the B (blue) field. Click OK. Now double-click the Gray (middle) Eyedropper and enter 130 in each of the RGB fields, then click OK. Finally, double-click on the White Eyedropper and enter 245 in each of the RGB fields. When done, click OK and a box will open asking if you want to "save the new target colors as defaults." You do, so again click OK. This will now save those values as defaults for the Eyedroppers for both the Levels and Curves (in Photoshop CS) functions.

3. Using PC, go to Edit>Preferences (in Apple OS, go to Photoshop/Photoshop Elements>Preferences). Select Display & Cursors from the Preferences drop-down. Under Painting Cursors, choose Full Size Brush Tip. This shows the full area affected by the brush. Feel free to scroll to review and customize other options in Preferences.

Color Space

Go to the Edit > Color Settings (in Photoshop Elements > Color Settings). The Color Settings window opens. For Elements 5.0 and higher, choose Always Optimize for Printing, and you're done. For Photoshop CS, continue with the following steps:

1. At the top of this window, click on the Settings drop-down menu and choose North America Prepress 2. You'll see that making this choice also changes the RGB working space to Adobe RGB–a versatile and accepted color space for photographers. Most amateur photographers can ignore the settings for CMYK, Gray, and Spot because these are for people doing prepress work (primarily magazine/newspaper production). If you shoot for prepress, you may want to click on the RGB drop-down menu (Working Spaces) and select ColorMatch RGB because its colors better approximate the CMYK colors used in prepress. If you decide to work solely in the ProPhoto space because of its wider gamut, click on the RGB drop-down menu (still under Working Spaces), and select ProPhoto (the settings entry will change to Custom).

2. Still in the Color Settings window, go to the Color Management Policies section. Here you can decide how to handle files with color spaces different than your preference. Generally, it's best to convert them to the space you chose in step 2.

In Color Management Policies section, click on the RGB drop-down menu and select Convert to Working RGB. Note that making this selection also changes the Settings entry at the top of the window to Custom. That's okay, because all the other settings you made have been preserved.

Uncheck the boxes for Profile Mismatches. Leaving them checked causes a dialog box to pop up and ask what you want to do every time you open a file with a different color space, such as sRGB. You almost always want to convert it to your working color space, so there's really no need to be constantly asked the question.

This photo achieves its purpose, selectively showing sharp focus on the hayroll while the farm and field blur gradually into the background. But you should not be afraid to delete photos that are flawed rather than spending a lot of time adjusting them.

Choosing Which Images to Adjust

Adjusting pictures to reveal their ultimate image quality begins with the selection process. You should choose images that demonstrate ultimate potential. Put another way, you should avoid images that are hopeless. Although there may be times you need to reclaim images that have been mistreated during the act of picture taking, this is not one of those times. You may object, but think of it as shopping for a new car. Would you buy one with scratches, dents, cracks in the windshield, or flat tires? The answer is maybe, if it's fixable so it will look like new (and you get a good discount). But generally you would pick a new car (or image) that is in tip-top condition.

So pick only those images that have the potential to be perfected. In seeking perfectibility, what should you look for in an image and how should you confirm it meets your criteria for becoming an ultimate image? And equally important, what images should you avoid? Maybe, that's easier. Let's start with images to avoid.

This JPEG was shot with the white balance set to tungsten. The poor color plus uninspired composition means it's unlikely to become an ultimate quality photo.

Doomed Images

Certain flaws doom an image. No matter how good your Photoshop skill, no matter how much you love them, images with such flaws are incapable of ultimate image quality. Don't choose images that show these fatal faults:

- Photos Blurred by Poor Focusing or Insufficient Depth of Field

 You simply can't make adjustments that overcome focusing or severe depth of field problems. No amount of sharpening will ever correct for an object that is out of focus.

- Images Blurred by Camera Shake

 Again, no software adjustments can overcome blur from camera shake. If blur is slight, you may make an acceptable image, but it won't achieve ultimate image quality.

- Pictures Requiring Severe Cropping

 Let's call severe cropping an amount that eliminates one third or more of the image area. That reduces the resolution too much for achieving ultimate quality–unless you're content with making a small print.

- Severe Aesthetic Problems

 We've mostly avoided aesthetic issues because they are so subjective. You decide what meets your aesthetic values, but if an image falls far short, don't expect to rescue it in Photoshop. Bad composition is simply bad composition.

- Severe Color Balance Problems in JPEG Images

 Did you take a JPEG picture in tungsten or fluorescent lighting using a white balance setting for Daylight (or vice versa)? Were you in a difficult mixed lighting setting (tungsten, daylight, and fluorescent)? Depending on the severity and whether you have any neutral image tones to guide your work, you might be able to enhance the photo and maintain high image quality, but achieving ultimate quality will be difficult.

- Medium or Low Quality JPEGs

 Too much compression eliminates too much data, causing minor but definite flaws, especially noticeable in areas of uniform tonality (skies, faces, etc), edges (JPEG jaggies), and fine detail. Though certain subject content (images with a lot of varied detail and tones) can disguise some flaws, achieving ultimate quality becomes a problem.

- Severe Exposure Problems

 Though the RAW file format helps overcome less than optimal exposure, it can't perform miracles on severe problems. Give it a try, but don't expect to match the quality of an image that was correctly exposed.

Pictures with Potential

You know which pictures to avoid. Now determine the ones to keep. If you bracketed exposure and composition to create several variations, choose the one with the greatest potential.

Your first decision, which only you can make, is to rank those pictures that you like best, that are creative and meet technical criteria for well executed photographs. Superior images should demonstrate:

- RAW file format (okay, a dead-on JPEG will work)

- Good exposure

- Sharpness

- Accurate and attractive color

- Aesthetic appeal

To evaluate exposure, use a program that displays the histogram. If the histogram seems questionable and doesn't display a distribution of tones that reaches the graph's axes without butting against them abruptly, open the image in Camera Raw and work with the adjustment controls, particularly the Exposure slider, to see if you can bring the tonality within the histogram's boundaries.

If you use Bridge, you'll have to visually evaluate the exposure because that program lacks a histogram. Your visual evaluation will simply confirm that you believe the tonal range of the image falls within the adjustment capabilities of Camera Raw. You can do that fairly reliably for a RAW file, not quite so reliably for a JPEG file. To analyze sharpness, inspect critical areas at 100% magnification. In CS3, Bridge has a nifty magnifying glass/loupe that lets you do this with a preview image.

The loupe in Adobe Bridge magnifies portions of the image so you can evaluate sharpness.

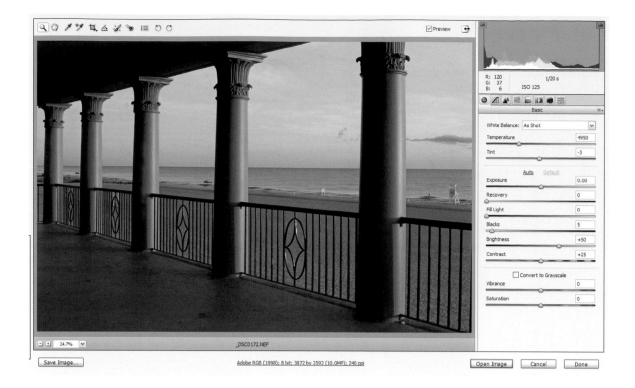

Opening the Image

Your primary goal in using Camera Raw is to create an image with optimal tonal range and correct color balance while retaining as much data as possible. Whichever Photoshop software you're using, when you view a picture shot in RAW file format, the program automatically uses Photoshop Camera Raw to open the image.

Camera Raw gives you several options from which to choose that have an impact the quality of your picture. Some of the choices are:

- 8-bit versus 16-bit images

- File resolution size (available in Photoshop CS only)

- Color space (not available in Elements)

- White balance setting

- Auto adjustments

Camera Raw Settings

If you have versions of Camera Raw that predate 4.0, the descriptive steps and settings that follow may vary slightly from what you will see on your interface, but the general procedures remain sound. If you have Photoshop CS3 (or higher), choose your settings as follows:

- Open a RAW file so you get the Photoshop Camera Raw window.

- Press Cntrl/Command K to open the Camera Raw Preferences Window

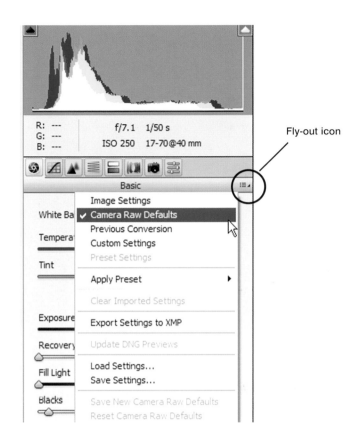

Fly-out icon

- In the upper section, click on the drop-down menu for Apply sharpening to and select Preview images only. This way, the image in the preview window will be sharpened but the actual image won't. It is better to sharpen in Photoshop because that program's sharpening functions give you greater control than those in Camera Raw.

- Now examine the section for Default Image Settings in the Camera Raw Preferences window. Uncheck the boxes next to Apply auto tone adjustments and Apply auto grayscale mix when converting to grayscale. If you leave an "Auto" adjustment turned on, the image will be altered when it first opens in Camera Raw, so you don't really know what it looks like. You can still apply the Auto features in Camera Raw after opening your image if you want to see the results they give, although I prefer not to use them.

- Click on the Preview box at the top of the window. Turn on the displays for both shadow clipping and highlight clipping by clicking on the triangles at the top left and right corners of the histogram.

- At the bottom center of the Camera Raw window (beneath the image in your workspace), click on blue underlined text link that identifies the color space, bit size, resolution, and ppi. It opens the Workflow Options dialog.

When you open the underlined link below Camera Raw's work area, the workflow options will display. See the sidebar on the following page for more detailed information about these choices.

- Space

- Depth

- Size

- Resolution

Click on the fly-out menu icon, and choose Camera Raw Defaults (triangle in upper right of Camera Raw window). Now when you open a photo, it will display qualities based on the camera settings used to take the picture. If you don't set it that way, adjustments will be made automatically without you seeing what the actual image looked like. You may later change these settings, but it's best to begin your processing by seeing what the image actually looks like as recorded by your camera.

Photoshop Camera Raw Workflow Options

• Space (not available in Elements)

Your choices for color space include Adobe RGB (1998), ColorMatch RGB, ProPhoto RGB, and sRGB. ColorMatch RGB is often used by photographers shooting for press publication. ProPhoto RGB has a wider gamut than the others. Theoretically, it should preserve the widest range of colors. Adobe RGB (1998) offers a slightly lower (but still expansive) color gamut, while sRGB offers the smallest gamut; but both are widely used in the photo industry so they can be handed off to labs with minimum trouble. I use Adobe (1998), but play with ProPhoto RGB because it has been gaining support. In reality, it can be quite difficult to discern differences between images printed in the various spaces, even though theoretically ProPhoto RGB offers a substantially larger gamut.

• Depth

If your image is poorly exposed, go with 16-bit depth to preserve the largest amount of information available while you manipulate the tonal scale. If your image is well exposed, you can probably use 8-bit depth without giving up much quality while gaining the speed and convenience

of using smaller files. Although many Photoshop CS features and functions work at the higher bit depth, certain adjustments may force you to convert to 8-bit mode before you can apply them. When in doubt, make your tonal changes at 16-bit depth, and then convert to 8-bit mode. Files with 16-bit depth are twice as big as 8-bit images, so your computer needs lots of RAM (1.5 GB RAM or more would be advisable) to handle large images.

• Size

The Size drop-down menu gives you a range of smaller and larger file resolutions to choose from when opening the RAW image. I'd suggest choosing the resolution native to your camera. It will be the size shown without a + or a − following it in the drop-down choices.

• Resolution

The default is 240 ppi. There's no need to change it now. If you do change it, the software will interpolate the image accordingly.

Two-Stage Adjustment Strategy

The best strategy is to adjust your image in two stages. For stage one, make overall adjustments to tonality and color that prepare your image for fine-tuning. This is the equivalent of a sculptor taking a block of wood and creating a rough shape of the form he is working on. For your rough shaping, you'll be using Photoshop Camera Raw. There are advantages to manipulating even JPEG images in Camera Raw.

For stage two, you'll need to use a recent version of Photoshop CS or Elements. At this stage you undertake the many refinements that are almost always necessary to enhance and retouch all potentially ultimate images, including adjustments for local color and tone correction, resizing, cloning, sharpening, and alterations for color-proofing based on print tests. You will use these programs because they offer the selection and numerous other adjustment tools, along with layers, that let you easily apply local fine-tuning.

Stage 1: Tonal and Color Adjustments

Photoshop Camera Raw is especially nice because it lays its tools out in the sequence commonly used for adjusting images. Now that's intuitive. If the picture is well exposed, adjust color first, and then the tonal range, although it doesn't really matter if you do it in reverse. If either exposure or color is far off the mark, you probably should first adjust the one that needs it most. In such instances, I usually prefer to adjust color first because it's often a simple adjustment that's easily revisited after you work on exposure.

Camera Raw excels in adjusting the overall color balance and tonal range of your picture because, unlike Photoshop, it preserves the original data in a mostly "uncooked" or unfinished form. What does that mean as far as end results? Camera Raw will carry out smooth transitions in images that need broad tonal adjustment, including areas like skies and faces. It

Adjustment	Camera Raw	Photoshop
Tonal range	Best for RAW files, good for JPEG. Allows about +/- 2-stop exposure range adjustment, and exceptional control of highlights and shadows.	Good for overall adjustment of correctly exposed images. Best for adjusting local tonal problems.
White balance	Best for adjusting (normalizing) the overall white balance and handling mixed lighting.	Allows fine-tuning through click-balancing with adjustable eye droppers.
Color control	Good for adjusting color temperature, tint, and overall saturation.	Best for fine adjustment of color and saturation, specifically of selective areas.
Sharpening	Okay for general sharpening.	Superior control of sharpening.
Selective adjustments	No selection tools so you can't selectively adjust color, contrast, tones, sharpness, saturation.	Superb selection tools.

means you will be able to recover details lost from overexposure and reveal the tonal nuances of towering cumulus clouds, the lace on a wedding dress, or the slats on a sunlit picket fence. Similarly, you can open up underexposed shadows to show the cracking on burnt driftwood, the pockets on a black tux, or the texture of bark on a shaded tree trunk.

Think of a room in your house. Using Camera Raw is like choosing the color and brightness of the paint for the walls and ceiling to create an overall effect. With Photoshop, you refine the room through hundreds of additional flourishes, retouching the rough spots, doing the trim, adding window treatments and carpeting, furnishings, wall decorations, selective lighting effects, and so on.

Adjusting Color

Color adjustments can take two directions: color accuracy (correction) and color preference (creative control). It's easy to think of color accuracy as creating colors that match those in the scene. But since matching the real world is nearly impossible, let's use the verb approximate. We'll approximate the real world–not match it. And remember that color preference is simply creating colors that we as individuals like.

Photoshop Camera Raw offers several tools for correcting color (see the Camera Raw window on page 86):

- White balance setting (which sets the color temperature to a predetermined setting).

- Color temperature (lets you select any color temperature along a blue-yellow scale).

- Tint (which lets you shift color along a green-magenta scale).

- White balance eyedropper (which you click on a neutral area).

- Hue sliders.

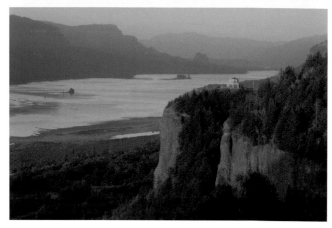

The top photo is color accurate, while the bottom image has been adjusted for creative purposes. By adjusting the color of the water and cliffs, I created a more dynamic effect.

You can also use these tools for creative color control as well as the saturation, hue, and luminance adjustments under the HSL/Grayscale icon.

At first glance color accuracy might seem to be the way to go. After all, if you saw a scene that appealed to you, then you probably want to replicate it–color and all. But I think most of us are more creative than that. We want to create a photograph that represents our vision. Thus we start out with an appealing scene and turn it into a compelling picture. In the end, we probably have a hybrid approach, mixing color accuracy with color preference. Of course, if you are a product photographer, you may need to accurately represent the color of your objects. However, if you don't make your living by making sure colors are perfectly accurate, don't slavishly make neutrals such as white blouses and snowy fields precisely neutral just for the sake of accuracy. If the move benefits the overall picture, fine. If it doesn't, go part way toward neutrality, or hold back entirely. Whatever works for the picture is the best choice.

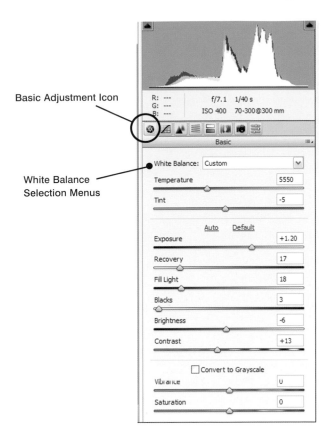

Basic Adjustment Icon

White Balance
Selection Menus

Note: The key to correcting color, be it for color accuracy or creative color preference, is a calibrated monitor (see pages 38-39). You can't adjust color with confidence if your monitor is not calibrated. (Well, you can adjust by the numbers, but you won't be able to visually confirm what you're doing.) And for photographers, seeing is all. So calibrate that monitor. And if you're an inkjet printmaker, you should profile your printer (more in the printing chapter).

Let's start by learning how to adjust images to approximate accurate color. And then we can decide whether to creatively improve them. The path to color correction actually begins during the picture-taking process. Before taking the picture, create a manual white balance setting (see your camera's user guide) by using a white balance tool, such as a gray card, white card, or ExpoDisc. This will adjust the temperature of the recorded light to a value of about 5500K (midday sunlight). If you do this with the light from a sunrise or sunset, the effect can be disconcerting because the image's colors will vary dramatically, not only from your memory, but also from reality.

Fortunately, if you shoot using your camera's RAW format, you can always change the color temperature in Camera Raw to a setting that represents the actual scene. Alternatively, you can put a white or gray card in the scene and click-balance on it when adjusting the image file in Camera Raw or Photoshop.

Follow these steps to make proper color adjustments:

1. With the picture open in Camera Raw, click on the Basic adjustment icon (little drawing of an aperture diaphragm).

2. Camera Raw gives you several choices to adjust color. If you created a manual white balance before shooting, the color should be fairly accurate and may not need further color adjustment. If you decide to make an overall color adjustment, use one of these methods:

a. Select the White Balance eyedropper and click on a white or gray area that is supposed to be neutral. Note that when you place the eyedropper over an area, the RGB values for that area appear under the histogram.

b. Click on the White Balance drop-down menu. Select a white balance setting corresponding to the lighting at the time you took the picture. If you manually adjusted the white balance of your camera, be sure to choose As Shot for your white balance setting. Note that the Kelvin temperature value in the cell below changes to represent the white balance setting you choose from the drop-down menu. If you don't like the results, choose another white balance setting or adjust sliders as described in step C on the following page.

c. Adjust the Kelvin temperature slider until the image matches your expectations. Unlike the fixed white balance settings, this slider lets you choose any temperature value. Its slider bar is colored to represent the color you are adding to the picture. Slide to the left and you increasingly add a blue cast (cool); to the right adds orange (warm). If the Daylight WB setting of 5500 is still a bit too warm, slide the Temperature value to 5200K or 5000K. If the Cloudy WB setting of 6500K is too cool (bluish), slide it to the right to 6800K or whatever you like.

d. Adjust the Tint slider to add green (when you slide it left) or to add magenta (when you slide it right).

3. You can increase color saturation by using the Vibrance and Saturation sliders, which give an overall boost to all colors. The Vibrance tool does have the advantage of evaluating the degree to which colors are saturated in the image and proportionately increasing saturation to colors that need it–thereby avoiding over saturating or clipping colors.

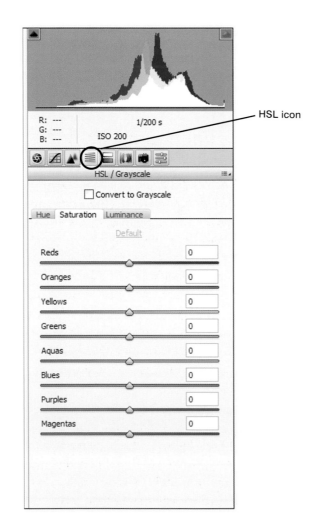

HSL icon

4. Or you can use the sliders under the HSL/Grayscale icon to adjust specific colors for hue, saturation, and luminance. Their greater precision makes them a better choice than the Vibrance and Saturation sliders in step 3.

Whichever tools you use, be gentle with their application. Making an adjustment that is too strong can cause problems later. Photoshop CS and Elements provide excellent tools for refining saturation later in the workflow, when you probably have a clearer idea of what you want. When you finish with the steps above, the color in your picture should be fairly accurate so it's ready for smaller, and perhaps more subjective, local fine-tuning in Photoshop.

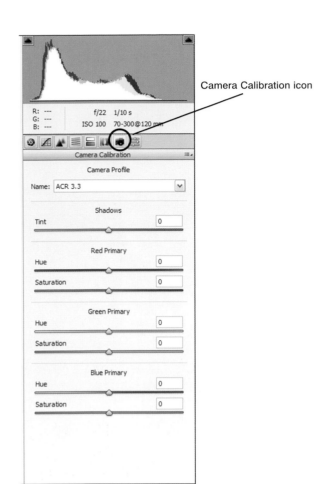

Camera Calibration icon

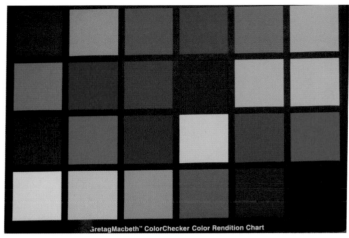

By photographing a Macbeth color chart and adjusting the file with the Camera Calibration tool, you can create an approximate camera profile.

The Camera Calibration Tool

The Camera Raw Calibration tab lets you adjust colors and then save the changes and apply them to future RAW images. It's like a visual profile of your camera. The intent is to consistently provide accurate color by simply opening the image in Camera Raw according to those preset adjustments. Should you do it? Well, give it a try on a rainy day and see what you think. Like all visual adjustments, it's subject to the whims and short-comings of your vision and personal color biases, not to mention that the calibration becomes somewhat invalidated if you shoot in different lighting than used for your test image.

If you decide to give it a try, you must photograph a subject of known color. Not just red like an apple or yellow like a lemon–but a subject with colors that are precisely documented by specific RGB values. In other words, you need a Macbeth color chart that provides a series of color and neutral patches of known values (see adjoining illustration). Make a photo of this color chart

in RAW and open it with a preset white balance selection, such a Cloudy or Daylight. In the Basic mode of Camera Raw, set the tonal values to approximate the white, black, and gray patches on the chart. Then go to the Calibration tab and adjust the colors as closely as possible to approximate the color patches, matching the known values (it's a bit of trial and error, so you won't get it perfect). When you're done, click on the fly-out menu and save the settings as New Camera Raw Defaults. If you don't like them, you can always reset to the Original Camera Raw Default settings.

This calibration, however, works well only if you shoot in lighting conditions similar (and ideally identical) to those used to photograph the Macbeth chart. You could create a series of calibrations to represent the common lighting conditions in which you often photograph. But if you're an outdoor photographer, you might find it easier to simply use a white/gray card to create a custom white balance or to place in the scene to use later during adjustments in ACR.

Color Primer

You probably know how color is created with light, but here's a refresher just in case. As Sir Isaac Newton (as in apple falling on head) demonstrated with a prism back in the 16th century, daylight consists of several color components. Combined equally, those components form white (neutral), or what we might call natural, light. It is the sunlight of midday.

The colors that form neutral, or white, light are red, green, and blue. These are the primary colors in the light we photograph. Mixing two primary colors creates secondary colors: cyan, magenta, and yellow; which are also the ink colors used when printing. When adjusting color, you can achieve similar results by working with the primaries or secondaries. For instance, blue and yellow form one primary-secondary combination (also referred to as additive-subtractive). If an image is too yellow, it seems obvious to decrease the amount of yellow. But you can also increase the amount of blue, thereby offsetting the yellow. You can also use this approach for red-cyan and green-magenta.

Memory Colors: Our interpretation of how certain subjects should appear is affected by emotion and memory: Your mother's face, your neighbor's lawn, that daydream of a sky. These are subjective evaluations. And while reality may depart from memory, these perceptions usually should be acknowledged. Confused? Don't be. In adjusting color, consider whether the sky is blue enough, the grass green enough, the apple red enough, the face flesh tone enough. These subjects have branded themselves into our memory by their color associations. In real life, an apple is seldom as red as we remember it or grass so green. But you should consider selecting such objects and shifting these colors if it would improve your picture. Don't overdo it, but don't ignore it.

Some subjects are more sensitive than others to color enhancement. Most sensitive may be white subjects. For example, a wedding dress should be pure white, without a hint of yellow, pink, or chartreuse, while other white subjects like clouds or sweaters may yield to slight color shifts and be acceptable. But if an object is white, consider keeping it white.

Adjusting Tonality

Once you've adjusted color, you're ready to adjust tonality. You should still have the Basic adjustment panel open. You'll be using the Exposure, Recovery, Fill Light, Blacks, Brightness, and Contrast sliders.

Generally, you'll try to adjust your RAW photo file to obtain the widest range of tonality possible while maintaining detail throughout the dark (shadow) and light (highlight) areas. There will always be exceptions, such as a foggy harbor scene where the mood is carried by the narrow tonal range. Using a calibrated monitor, this is primarily a visual analysis, but you should also rely on physical indicators to reveal problems, such as the Shadow and Highlight clipping displays, as well as the histogram.

Here are the instructions for tone adjustments in Camera Raw:

- Open your RAW photo in Camera Raw. Make sure you can preview your alterations and that the clipping displays for highlights and shadows are active. If dark areas of your picture are being clipped (losing detail), a blue highlighter paints over the affected areas. If light areas of your picture are being clipped (again, losing detail), a red highlighter paints over the affected areas.

- Click on the Basic adjustment icon (little drawing of the aperture diaphragm).

- Review the image for your overall impression of color, brightness, and contrast. Check to see if important highlights or shadow areas are clipped. Look at the histogram to see whether or not it indicates the expected tonal range

Note: If you don't like keeping the clipping previews constantly active, you can hold the Alt or Command plus Option key to see clipping while adjusting the Exposure, Recovery, and Black sliders.

The highlight preview feature in Photoshop displays overexposed areas in red.

- You'll likely go back and forth between the sliders to balance your overall adjustments. In other words, you have to play with them to get the look you want. The table on page 106 indicates which sliders to use in order to adjust for different issues. If you decide you need to start over, click on the fly-out menu icon and choose Camera Defaults. But beware; this will reset the image back to what it looked like coming out of the camera.

- Again, your goal is to optimize the overall tonality, making the color and tonality as good as possible before sending it to Photoshop for further refinement. You aren't seeking perfection at this point, so don't overdo contrast adjustments (though you definitely should avoid clipping the highlights and shadows).

- If you plan to continue adjusting the image, click on Open Image (Photoshop Camera Raw) or Export (in Lightroom Library) and the enhanced file will open in Photoshop CS.

The original shot (left) isn't bad, but you can improve the dynamic range and give more presence to the photo by using the technique described here to adjust both the highlights and shadows (right).

Extending Tonality in Photoshop

There are at least two methods you can use to substantially extend tonality (dynamic range) beyond that captured by a single image. We looked at one of these, HDR, earlier (see pages 60-61). The other technique, which won't match the range of bracketing exposures and combining them with the HDR function in Photoshop, is effective nevertheless. It combines two images of different tonal variations from the same RAW file.

Since you're dealing with a high-contrast image, your goal will be to adjust the file one way so it captures highlight detail, and adjust it a second time to reveal shadow detail. You will make the initial adjustments in Camera Raw and then combine the two images in Photoshop.

Adjust for Highlights

1. Open the file in Camera Raw. Make sure the high light clipping preview is turned on and Auto adjustments are off.

2. Evaluate the highlights. Are they clipped as indicated by red shading? If not, adjust the Exposure slider to give you appealing highlights (ignore the shadows at this stage). Also look at the histogram to make sure the graphs aren't pushing too close to the right axis. You can fine-tune the adjustments with the Brightness and Contrast sliders.

If the red shading fills substantial or critical areas of the highlights, you're losing too much detail. It's okay to lose highlight tones in specular areas, such as the sun, a light bulb or sun-dappled water. But it needs to be addressed if it's an area that should show detail: a white dress, gray hair, a snow bank, a cloud, and so on.

3. You may be able to eliminate limited clipping by moving the Recovery slider to the right. If that's not enough, also move the Exposure slider to the left. You may then want to adjust the Brightness and Contrast sliders to make the highlight more appealing. Be careful, as increasing Brightness and Contrast can cause more clipping.

When done, open the image into Photoshop.

Adjust for Shadows.

1. Open the same RAW file again in Camera Raw. Make sure the shadow clipping preview is on and Auto adjustments are off.

2. Evaluate the shadows. Are they clipped as indicated by blue shading? If not, simply adjust them with the Exposure and Blacks sliders to give appealing shadows (ignore the highlights) that show the detail you desire. However, opening the shadows too much may create unwanted noise. Before you finish, magnify the file 200% and look at the shadows for noise. If noise is excessive, darken the shadows a bit or apply noise control under the Detail tab.

3. If slight clipping appears in the shadows, you may be able to eliminate it by moving the Blacks slider to the left and the Fill Light slider to the right. If heavy clipping occurs, move the Exposure slider to the right to brighten the entire image until the shadows reveal detail withour creating excessive noise. Finish adjusting the shadows with the Contrast and Brightness sliders.

4. Open the image into Photoshop (If you have an older version of Photoshop, you may need to first save the file under a new name, and then reopen it).

Combine Two Images

1. Determine whether the highlight image seems best or the shadow image.

2. Select the Move tool (press V). Hold down the shift key and click on the better looking image and drag it on top of the other image. Holding down the shift key will align the two images.

3. Click on a layer mask (icon at bottom of Layers palette with circle in gray rectangle). It will be added to the new layer appearing as a white rectangle. You are now going to paint on areas of the upper image where you want to show qualities of the layer below

4. Select the Brush tool (press B or click on it in the toolbox) and set an appropriate size. Make it fairly soft, but when working along borders you may want it harder.

5. Set the foreground color to black (press X until the black square appears on top of the white). This allows you to paint on the upper image, removing protective areas of the mask where you paint.

If you're not used to this technique, play with the brush by clicking and dragging over the areas you want to improve. Undo the effects (CTRL/Option Z or the history palette). Try varying the opacity to see its effect.

6. Once you understand what effect the brush will have on your image, reduce the opacity to 15-30% and use multiple strokes to build up the effect by click-ing and dragging and releasing the click to activate the strokes you just made. You have to release the mouse and restroke to build up an accumulative effect.

7. Look at the image and see if the effects look natural. You can refine the layer mask by Alt/Option clicking on it and painting directly on it. To restore areas of the mask (and undo the effects you've created), press the X key and change the foreground layer to white, and then paint on the areas of the mask you want to improve.

Tone Adjustment in Photoshop Camera Raw

Description	Action	Watch out for
Overall picture too dark	Drag Exposure slider to the right.	Excessive clipping of highlights.
Overall picture too bright	Drag Exposure slider to the left.	Excessive clipping of shadows.
Excessive clipping of highlights (red shading)	Drag Exposure slider slightly to the left and Recovery slider to the right. You can also reduce highlight clipping by dragging the Brightness and Contrast sliders to the left.	Creating a tonality imbalance in which the picture just looks odd.
Excessive clipping of shadows (blue shading) or dark areas too plugged	Drag the Blacks slider to the left and the Exposure slider slightly to the right. You can also reduce shadow clipping by dragging the Fill Light slider to the right or by dragging the Brightness and Contrast sliders to the left.	Creating a tonality imbalance in which the picture just looks odd.
Dark areas of picture murky and muddy–no snap	Drag the Blacks and Contrast sliders to the right, playing with them to improve the appearance.	Don't overdo adjustments. Shadow detail is difficult to hold, and you can always adjust this further in Photoshop.
Bright areas seem dull, dingy, and lifeless	Drag the Brightness and Contrast sliders to the right playing with them to improve the appearance.	Don't overdo adjustments. Highlight detail is difficult to hold, and you can always adjust this further in Photoshop.

Evaluating the Histogram

The histogram is a statistical graph that displays the tonal or color values in your picture. In Photoshop, you can display a luminosity histogram in which only one graph represents all the brightness values. Or you can display a color histogram that combines three graphs, one each for red, blue, and green values. In Photoshop Camera Raw, you find only the color histogram

A histogram is valuable because it numerically shows whether you have captured a full range of tones in your picture. Running from total black (left axis of graph) to total white (right axis), the graph represents values ranging from 0 (pure black) to 255 (pure white) for an 8-bit image, or from 0 to 65,536 for a 16-bit image (there really are that many values, but the graph only depicts from 0 to 255). There is no typical histogram shape; it varies dramatically depending on the tonal values in the subject. A histogram for a properly exposed picture of a groom in a black tuxedo will look very different than one for a bride in a white dress.

Camera Raw's histogram charts the number of red, blue, and green pixels in the image.

Of immediate concern are the far right and left sides of the histogram. A large spike jammed against the far left, where the graph falls straight down the left axis, indicates the image is too dark and losing much shadow detail (underexposed if looking at it on the camera LCD). That tux would be pure black with buttons and pockets and lapels lost in the darkness. The groom's face would be quite dim, and his hair, unless blond or white, would be a murky mess. On the other hand, graphical spikes jammed at the far right indicate the image is too bright (overexposed if looking at it on the camera LCD). The lace, beads, and filigrees on the bride's dress would be washed out, and without detail, her face would look exceedingly pale. In short, the whole image tends to look out of whack when the histogram shows values concentrated against the far right or left axes. Move the sliders in the Basic panel to see the effects each has on the histogram.

Because you're careful with exposure when taking your picture, you probably won't encounter such extremes very often. You'll be more concerned with the subtle losses when only a small portion of the scene, like a forest shadow or part of a cloud, nudges the extreme. While it may not harm the photograph, it does indicate subtle loss of detail. If you're shooting RAW, you can likely recover that detail, but that's also why I recommend bracketing exposures: one of them has a good chance to capture the entire dynamic range. Of course, high contrast scenes with a 6-stop or greater dynamic range may exceed your sensor's capability and will show that with shadow or highlight (or both) tonal values jamming against one end of the histogram. When you want to preserve highlight and shadow details in such scenes, consider using the HDR technique.

If the histogram seems to be bunched towards the middle with few values shown tapering to the far left and far right, you may be able to improve the image by increasing the contrast. Do that in Camera Raw by moving the Contrast slider, or by sliding both the Brightness and Shadow sliders to the right until the histogram expands towards the extremes. Turn on the shadow and highlight-clipping preview so you can see if your adjustments have gone too far.

The Tone Curve divides the tonal range into four segments on the curve. You can either manipulate the curve manually or use the sliders to make an adjustment.

The Tone Curve

So far we've used only the intuitive sliders in the Basic adjustment panel. But your version of Camera Raw likely also offers a Tone Curve function. Utilizing the curve tool gives you great precision in making your adjustments. If you prefer using this tool, by all means go ahead. The selection for curve follows the Basic tools in the workflow. Starting with Camera Raw 4.0, Adobe offers a choice of adjusting this function either point-by-point on the curve, or by choosing from a series of sliders that individually addresses four areas of the curve (highlights, light tones, dark tones, and shadows). These sliders are actually quite nifty. Though not quite as precise as manipulating the curve, the sliders are an intuitive introduction to adjusting the tone curve.

Correcting Flaws

Although most images exhibit a variety of flaws, Camera Raw offers only a few tools for fixing them, such as cloning and healing tools for spot-retouching, noise reduction sliders for luminance and color, and lens correction ability to manage chromatic aberration and lens vignetting. Most flaws will need to be fixed during the second segment of the two-part adjustment process, in Photoshop CS or Elements. Photoshop possesses more powerful cloning, healing, and noise reduction tools. With Photoshop, you can isolate the areas where you want to reduce noise, which does not alter the entire image with universal noise reduction (and detail reduction) in the way Camera Raw does.

However, the tools in Camera Raw's panel for Lens Corrections are definitely worth using. These sliders reduce chromatic aberration or lens vignetting (darkening of the corners common with wide angle lenses). To decide if you have a chromatic aberration problem, set the image display to 100% and examine high contrast border areas, such as the white balcony and black handrail against the blue sky above.

If a colored fringe runs along the high contrast edge, you have a problem. Simply choose the slider whose name corresponds to the color of the fringe and play with it until you minimize the problem.

To determine if vignetting is a problem, set the display so you can see the entire image and note if the corner areas look significantly darker than the rest of the photo (This effect is most noticeable with uniform midtones, such as skies and fields of snow). If so, slide the Lens Vignetting tool a touch to activate the Midpoint tool below it. Set the Midpoint value to a low number

(10 to 30) if the vignetting is slight to moderate and to a higher number (>30) if vignetting is more substantial; higher Midpoint values extend the area you adjust. If the corners are too dark (the most common condition) move the Lens Vignetting slider to the right. Too light? Move it to the left.

Stage 2: Making Final Adjustments with Photoshop

The adjustments you made in Photoshop Camera Raw have readied the image for final adjustment stages–sort of like prepping it for surgery. In our case, cosmetic surgery. And like a surgeon, you want the best tools available, which would be the tools in Photoshop. With them you can do anything. And that's a problem.

Photoshop allows you to make so many adjustments to brightness, contrast, color, sharpness, blemishes, perspective, and so on, that it's easy to go too far. Beware of overdoing selective adjustments and creating an artificial appearance. You don't want your photo to look perfect, or it may appear as unnatural as a sixty-year-old movie star without any wrinkles.

You want to treat your photo as an organic whole; something that just "looks right." Think of something that does not have an organic appearance: Apples that are too red, skies too blue, teeth that are too white, or butterflies too sharp for the flowers they rest on. As you make your changes, step back and look at the picture in its entirety. Does it seem natural? Make sure all the contributing elements come together to improve the overall picture.

Best Photoshop Practices

Like an incredibly powerful racecar, Photoshop gives you the potential to career through corners at 120 mph, or crash into the wall. By following accepted best Photoshop practices, you increase the odds of keeping your pictures on the path to ultimate image quality as you refine and polish them.

- **Use Adjustment Layers or Convert Pictures to Smart Objects**

 You should avoid altering pixels when making adjustments. Utilizing these options allows you to easily undo changes without harming the image. These tools are considered nondestructive because they make adjustments on a layer that changes the appearance of pixels without actually modifying the digital data. Plus, they give other options in adjusting the appearance of images, such as layer blending effects and the ability to manage opacity.

- **Avoid the Auto Adjustments: Auto Levels, Auto Contrast, and Auto Color.**

 It's not that these tools never do a good job, but it's more difficult to achieve your intent because they are not made for fine-tuning and tweaking; they are intended for quick fixes, not ultimate quality.

- **Use Levels or Curves to Adjust Tonality and Correct Color**

 The Levels tool works fine for simple adjustments. The Curves tool offers greater precision by letting you pinpoint the tonal and color values to be adjusted. Both let you address specific colors by choosing a red, green, or blue channel. Make these adjustments using an adjustment layer.

- **When Making Adjustments Use a High Bit Depth**

 Use 12 or 16-bit, depending on your Photoshop version, as far into the adjustment process as possible. This maximizes the data available and minimizes future problems such as splotchy midtones and noisy shadows. Make all tonal range adjustments with a high-bit image. Not all Photoshop functions will work on high bit depth images, but before you convert to 8-bit, complete your tonal and color corrections.

- **Don't Simply "Eyeball" Tones and Colors**

 Evaluate your images using measurement tools. Use the histogram to make sure your picture is meeting its tonal-range potential. Use the Color Sampler Tool (click and hold on the Eyedropper) and the Info tab to analyze the RGB values making up a color. Use clipping features (hold down the alt/option key when adjusting Levels or Curves) to get a quick visual indication of possible problems.

• Feather Selections

When you select and alter just a portion of the picture, you normally should feather your selection–one, two, four, six pixels, sometimes more so it blends in with the rest of the picture. How much depends on the size of your selection, the amount of change you're making, the type of change, and the nature of the surrounding content. But if you don't feather the selection, you risk creating a defined and noticeable border that signifies the area has been changed. Use a mask to refine your selection so it blends seamlessly and become organic with the rest of the picture.

• Set the Color Balance for Your Image with the Eyedropper Tool

If you want neutrals to be truly neutral, use the white, midtone, and black eyedroppers in Levels or Curves and click on an area that is a neutral color (white for highlight eyedropper, black for shadow eyedropper).

• Adjust Images in the Right Sequence

Sometimes you create problems by making adjustments too soon or too late. Here's the workflow sequence most photographers follow: Crop and straighten the image; enhance overall color; adjust overall tonality; save the file (don't want to lose all that work); fine-tune specific areas for color; do the same for tonality; retouch the picture; and sharpen. Then again, save all that work as a layered file.

Read and practice continually to imporive your skills. The Photoshop Help menu is a free and easy way to learn about the program's functions. If you find Photoshop CS overwhelming, try Photoshop Elements. It's simpler but still quite powerful.

Cropping Your Image

As we've discussed, to make the best use of all those pixels you've purchased, you should compose your photo so you don't need to do a lot of cropping. However, sometimes you will need to crop in Photoshop. At this stage, there are usually two reasons to crop your image. The first is to improve its appearance by creating a composition that is more pleasing or that displays the subject better. The second is to produce an aspect ratio that matches the paper you are printing on.

There's nothing magical or mandatory about matching the aspect ratio of the paper you're printing on so don't automatically adjust your pictures just to correspond to the dimensions of the paper. Let artistic values determine the crop. If you later need to fit the picture into a specific frame size, you can matte it accordingly.

The bigger issue is to minimize cropping so you maximize resolution and the potential for printing a large picture. For print sizes up to 13 x 19 inches (33 x 48 cm), keep the resolution at 240–300 ppi. You can determine a picture's current resolution by going to the dropdown menu, Image>Image Size. If that window shows a size based on 72 ppi, make sure the "Resample" box is unchecked and then input 240 or 300 for the ppi setting to see what size the image will print. You can also use a lower ppi value, but if you go below 200, the print will become noticeably less sharp.

Fine-tune individual colors with slight adjustments to saturation and tone after you've made blanket color adjustments to the overall image.

Color Corrections

When you adjusted the RAW file using Camera Raw, you did an overall color correction. Now it's time to make final refinements to the overall color. Later you'll select and fix any portions of the picture that you want to tweak.

Consider two guidelines: Create color that appeals to you (but don't exaggerate saturation or unusual hue shifts); and make known colors, espically neutrals, look appropriate (though some creative effect is acceptable to impart a sense of atmosphere or emotion).

Also, make sure flesh tones appear natural and appealing, and evaluate objects with memory colors (grass, apples, blue skies, etc). In reality, grass isn't always forest green and not all apples are fire engine red. So don't feel compelled to adjust them, just consider your intent and how the colors aid in conveying it.

Check colors before changing any. Your calibrated monitor should prevent surprises, but use the Info drop-down menu to determine actual color values (Window>Info). Click on the eyedropper and point its tip at any neutrals you're concerned about. The R, G, and B values in the Info window should be within a few integers of each other. For example, a white picket fence in mid afternoon sunlight might give values of R=249, G=249, B=250.

If you want to determine before and after changes, first sample an area (click and hold on the eyedropper in the tools palette and select the Color Sampler tool). Now click on areas to see before and after changes as RGB values in the Info window.

Now that you've examined the photo both visually and with the Info tool, decide what color shifts are needed. Here's how to make them.

Using the method described here bright-ened the picture and shifted the colors from bluish (above) to more neutral tones (below).

Setting Neutrals

Photoshop gives you shadow, midtone, and highlight eyedropper tools to adjust neutrals in those corresponding areas. During the setup of CS, you set the appropriate values for each of those eyedroppers. If you'd now like to use them, here's how.

If you can visually identify the neutrals you want to fix, skip to step 6. If not, start out by finding those areas.

1. At the bottom of the Layers palette, click on the half moon icon (Create New Adjustment Layer) and select Threshold. You'll use it to identify the darkest and lightest areas of the picture.

2. Drag the slider under the histogram all the way to the left until the histogram is completely white. Then slowly drag it back to the right until a small black area appears—these are your shadow areas with the darkest tones. Press the Shift key down and click in the black area to mark it.

3. Now drag the slider under the histogram all the way to the right until the histogram area is totally black. Slowly drag it back to the left until white areas begin to appear. These white areas are the brightest area of your picture. Press the Shift key down and click in the white area to mark it.

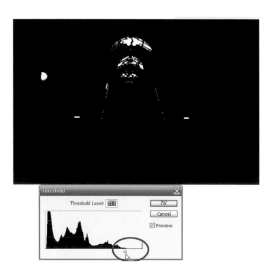

4. Click OK and close the Threshold window. Drag the Threshold layer to the trashcan to delete it. You don't need it anymore.

5. Click on the eyedropper in the Toolbox palette so the markers you just placed appear on the picture. (If you click on another tool, they will be hidden until you click again on the eyedropper.)

6. Now create a Curves adjustment layer by clicking on the half moon icon (Create New Adjustment Layer) and selecting Curves.

7. Click on the Shadows eyedropper (far left eyedropper) in the Curves window.

8. Place the Shadows eyedropper atop the No. 1 target (it's over the darkest area of the picture) and click on it. You have neutralized the shadows. How does the picture look? The changes should be subtle. If they look good, move onto the next step. If they're drastic and horrible, you probably clicked in the wrong area or put the target point in the wrong area. Undo the change by pressing Cntrl/Command Z, and try clicking the Shadows eyedropper in another dark area. If you can't find a good area to correct, you can simply adjust the curve itself (as discussed on page 107).

9. Click on the Highlight eyedropper (far right eyedropper) in the Curves window and place it atop the No 2 target (it's over the lightest area of the picture) and click on it. You have neutralized the highlights. If the change looks good, move on. If it looks bad, undo the change by pressing Cntrl/Command Z. Now try clicking the Highlight eyedropper on other bright areas that should be white. If you can't find a good area to correct, you can simply adjust the curve itself as discussed in the next section.

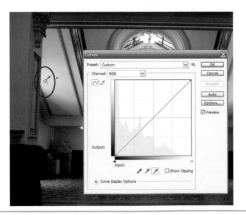

10. There's one eyedropper left–the Midtones. It's the middle one, so click on it. Now try to find an area that should be a neutral, medium gray and click on it. If you were successful with each eyedropper, your picture should now show a nice neutral color balance.

If you weren't fully successful or still want to shift color for creative reasons, the next section discusses how.

Color Adjustments

If you were successful in eliminating color casts from neutral tones but still want to adjust other color areas, decide whether you'll be making blanket changes or changes to specific areas (see page 116 to adjust color in specific areas without affecting other areas–such as those precious neutrals you have just adjusted).

If you weren't quite successful in achieving good neutrals or want to creatively change color, follow these steps:

1. Create a Curves Adjustment layer by clicking on the half moon icon in the Layers palette and selecting Curves.

2. Click on the Channel dropdown menu and select the color channel you plan to use for your correction.

3. If you fine-tune by changing a limited color range, use the following technique to identify the area of the curve to adjust: Hold down the Cntrl/Cmnd key and as you hold down the left mouse button, drag the cursor over the picture area to be corrected and let up the mouse button That action will set an adjustment point on the curve that corresponds to the color you want to adjust. Then click, hold, and slowly drag the adjustment point on the curve up or down. Observe as the color changes (refer to the Info window if you want to see actual RGB values). You don't have to move it very far to create significant modifications. Stop when you get the colors you want.

Rarely are such changes as simple as adjusting a single color, so you may have to tweak the curves in more than one color channel. And don't forget that you can lower the opacity to lessen the effect.

Color Refinements

If color is too	Do this
Red	Drag the red curve downward
Cyan	Drag the red curve upward
Blue	Drag the blue curve downward
Yellow	Drag the blue curve upward
Green	Drag the green curve downward
Magenta	Drag the green curve upward

If you find curves difficult to use, try using the Color Balance tool. Select it by clicking on the half moon icon at the bottom of the Layers palette to create a new Adjustment layer. Although less precise than Curves, it's easier to use, offering three sliders to adjust color. At the bottom of the window, choose the tonal area (shadows, midtones, highlights) where you want your color changes to occur.

Correcting Contrast and Brightness

Using Curves to increase contrast and brightness has become quite easy in Photoshop CS3. You simply select a menu item in the Curves window, and you're done–unless you decide to tweak it even more. If you are completely comfortable working with Curves, you can use the Curves layer you created for adjusting color. But if you're not comfortable with that, or if you like to keep major corrections on separate layers, then use a new Curves Adjustment layer.

1. Create a Curves Adjustment Layer by clicking on the half moon icon in the Layers window and selecting Curves.

2. The Curves window appears. To adjust contrast, click on the preset dropdown menu at the top of the window and try out the contrast items to see if any suit your picture. They all increase contrast. You can tweak the results by clicking on the points set on the curve and pulling the curve outward or inward. You can also analyze clipping by clicking in the Clipping box and dragging the Shadows (left) slider inward until part of the image begins to show. Whatever value is displayed at that point indicates where the shadows begin to clip. Now drag the Highlights (right) slider toward the middle until part of the image begins to appear against the black background.

3. To adjust brightness, create another new Curves adjustment layer.

4. Click on the Preset dropdown menu and select either Lighter or Darker to adjust the curve (which has the corresponding effect on the image). If you want to increase the effect you've selected, click the adjustment point on the curve and pull it so the curve bows out even more. Moving in the opposite direction reduces the effect.

Selective Fine-Tuning

Once you have adjusted the overall appearance, you can also adjust just the critical parts of the scene to subordinate or emphasize them. Typical examples would be to whiten teeth, saturate the rose in a vase, darken or eliminate distracting highlights just above the subject, increase contrast of a single element in the photo so it seems more three dimensional, or lighten shadows and darken highlights to better reveal detail. Achieving a deep black or a bright white, even if it's a small area, also helps make a photo pop.

Once you select specific areas you want to adjust, use a Quick Mask and a brush to make final refinements.

Follow these quick steps to enhance selected critical elements of your image:

1. Decide what portions of the photo you want to adjust.

2. Using a feather of 1-3 pixels, select the required area. You can use the lasso or the nifty Quick Selection tool in CS3. Enlarge the image to 100% and examine the selection to make sure it's good.

3. To refine the selection, press Q to activate the Quick Mask (a red mask protects the unselected area from changes). Press B to select the brush tool. To expand your selection, set the foreground to white and use to brush away the mask; to hide more of the selection, set the foreground to black and brush. Press the Q key again when you're done to show the active selection. When satisfied, save the selection (Select>Save Selection).

4. After you save the selection (make sure it's still active as indicated by the pulsing dotted lines around it), click the half moon at the bottom of the layers palette and choose the function appropriate for the changes you want to make:

- Curves or Levels for contrast and brightness changes
- Hue-Saturation for saturation changes
- Color Balance or Curves for color changes

5. To sharpen or blur a selective area, create a copy of the background layer (drag the background layer onto the new layer icon), then select the area you want to adjust. With the selection outline displayed, click on the Background layer to highlight it. Then apply the filter for sharpening (Filter>Sharpness>Unsharp Mask) or blurring (Filter>Gaussian Blur).

Retouching

We'll not dwell excessively on retouching, but you will want to examine your photo and see where you ought to use such tools as the Clone Stamp, Spot Healing Brush, or Blur to finish creating a near flawless picture. Be sure to enlarge the image to 100% before inspecting for flaws. When not working at 100%, choose a magnification that is a multiple of 25% (50%, 75%, 150%, etc), where Photoshop better displays the image. At odd sizes, like 33% and 66%, the interpolated image is of a lower quality.

Sensor dust spots, stray hairs and skin blemishes in portraits, discarded cigarette butts or telephone lines in a scenic shot, distracting dappled highlights in the background, flare rainbows, and other minor distractions are all candidates for elimination with cloning and healing tools. Retouch late in the workflow, after color and tonal corrections but before sharpening, and it is a good idea to retouch on a copy of the background layer (drag the background layer onto the new layer icon) if you're doing more than a few small spots.

Digital noise appears as a discernable colored pattern, often in pictures taken with long shutter speeds or high ISO. Photoshop has tools to help reduce noise.

Reducing Noise

If you are shooting with a D-SLR and are correctly exposing pictures using a low ISO, noise problems should be minimal. Noise usually appears in pictures taken with long exposures, at high ISOs, and/or in pictures overly corrected to compensate for gross underexposure.

To review your image for noise, magnify it to 100% and inspect the dark tones, (especially uniform dark tones, since they are most susceptible to noise). Using Photoshop CS, you can pinpoint noise by switching to Channels (Window > Channels) and inspect each color channel individually by clicking off all the eyeballs except for the one you want to evaluate. The Blue channel most commonly carries the most noise. But go ahead and look at the Red and Green channels also. The Reduce Noise tool in Photoshop CS will let you fix noise in each channel (addressing noise by channels is not available in Photoshop Elements).

You can address noise at a specific area in a specific channel by selecting it, or you can simply use the over-all noise reduction filter.

Here's how to fix noise.

1. Open the photo in Photoshop CS or Elements.

2. Enlarge the image to 100% (press Alt-Cntrl/Option-Command 0) and inspect the photo for noise problems, particularly the darker tones.

3. Create a new background layer by clicking on the background layer and then pressing Cntrl/Command J. Name the layer Noise Reduction.

4. Select the areas that need noise reduction with the lasso, marquee, or magic wand tools.

5. Go to Filter > Noise > Reduce Noise.

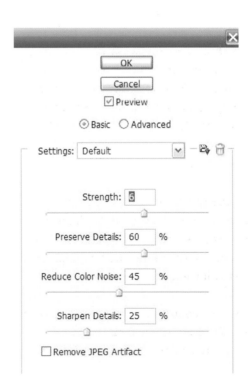

6. Decide whether to use the Basic or Advanced function (CS only). If noise is heavy in only one channel, use the Advanced function.

7. Click on the Preview button and view the area you are fixing at 100% (by clicking on the + or - under the preview photo).

8. In the Basic function (the only function in Elements), the controls are self-explanatory. Play with them to achieve an effect that is satisfactory. Keep in mind that aggressive noise reduction also reduces the amount of detail. To see the effects, click on the image and hold, which shows the "before" image; release and you'll see the "after" effects of the set-tings you've used. You're usually better off ignoring the sharpening function at this point (not available in Elements).

9. In CS, click on Advanced if you want to fix noise by individual channel.

10. Set the controls displayed on the Overall tab, then click on the Per Channel tab. Choose the channel to adjust, keeping in mind the Blue channel is usually the noisiest.

11. Using the sliders, set the values for Strength and Preserve Details until you see the best combination of noise reduction and detail preservation.

12. If other channels need noise reduction, select and fix them now.

13. Click OK when you are done. You can reduce the effect by lowering the opacity of the layer.

Correcting Lens Distortion

Lens distortions are most obvious on large subjects with straight lines and right angles–like buildings. The types of lens distortions readily displayed by such subjects include barreling (sides seem to bow outward), pincush-ioning (sides seem to bow inward), and perspective problems, such as buildings that appear to lean back-ward when you point the camera upward to photograph them (exaggerated by a wide-angle lens).

1. In Photoshop CS, go to Filter > Distort > Lens Correction. In Elements, go to Filter > Correct Camera Distortion. (You already fixed any chromatic aberration or vignetting problems in Camera Raw, but note you have a second opportunity to address these problems in this menu location as well).

2. If you need a straight-line visual reference, click to place a check in the grid check box at the bottom of the window.

3. To fix barreling, slide the Remove Distortion control to the right until the subject line is straight. To fix pincushioning, slide the control to the left until the subject line is straight. Photoshop CS also offers a control that lets you click and drag within the picture to create the same effects. To use it, click on the square barrel icon in the upper left corner of the Lens Correction Window. Then click and drag in your picture and you'll see the effects.

4. To fix perspective, use the Vertical Perspective and Horizontal Perspective sliders, adjusting them until the image looks right to you.

 a. Camera pointed upward at a building: Slide the Vertical Perspective control to the left.

 b. Camera pointed downward at a building: Slide the Vertical Perspective control to the right.

When you change the perspective, you actually change the overall shape of the photo so it is no longer rectangular, which leaves empty areas in the working area of your image. The easiest way to deal with this is to crop the picture so it is once again rectangular. However, the Edge drop-down menu at the bottom of the window gives you an option called Edge Extension. It does what it says, but is only helpful if the edge being extended is plain. So if you use it, expect to clone the edges it filled in afterwards.

5. Click OK.

If your D-SLR has a setting for sharpening, set it to a medium or low level. You can get better control and results by using the sharpening tools in computer applications.

Sharpening

Although some portraits, flower shots, and other photos may benefit from a soft look, most images need sharpening. How sharp an image should appear depends largely on the subject matter. Sharpening enhances the perception of detail and subtly boosts contrast to create an overall livelier photo. You can selectively sharpen to subtly emphasize specific areas of your photo. The risks of sharpening include the creation of edge artifacts and emphasis of noise.

Pictures need sharpening in part because most cameras use a blur filter in front of the sensor. The blur filter hides the aliasing that can occur when camera processing interpolates the missing colors captured by sensors using the checkerboard Bayer filter. Some cameras (and some RAW software) offer a moderate level of built-in sharpening that you can't turn off. But we're here to talk about sharpening you can control using Photoshop

CS. This enhancement is normally most effective when done near the end of your adjustment sequence, not in the early stages of Camera Raw adjustments.

Be aware that sharpening techniques are like "get-rich-quick" schemes: There are a million (okay, maybe only twenty) different ways, including a variety of plug-ins. The amount of sharpening to be applied depends on the file size, image content (portrait, landscape, flower, architecture), and your personal tastes.

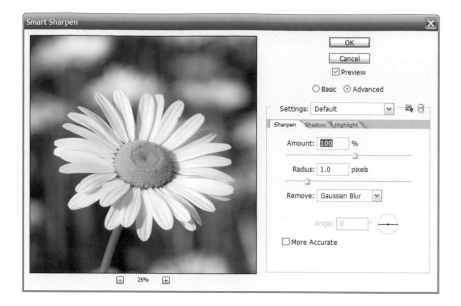

Smart Sharpening in Photoshop

Adobe added Smart Sharpening to Photoshop's first edition of CS. The feature's two major enhancements over the popular Unsharp Mask tool include a reduction of halo artifacts along edges and more control over sharpening by tonal range (highlights and shadows). It also has an advanced mode that offers additional items to fine-tune control. However, it lacks the Threshold setting found in Unsharp Mask. The Threshold setting lets you limit sharpening by tonal range and is very helpful in portraits to minimize excessive sharpening of flesh tones.

You generally have to sharpen more than you would anticipate when judging the image on your monitor, which tends to exaggerate sharpness compared to how a print will appear. Some people like to flatten the image before sharpening because they then have a smaller file that will print more quickly.

Here's how Smart Sharpening works:

1. Flatten the image and save it under a new file name. Then create a new layer on which to sharpen by pressing Cntrl/Command J.

2. Go to Filter>Sharpen>Smart Sharpen. Check on the Preview box.

3. Click on the Advanced button. You can use the Basic but why not take advantage of the additional features under Advanced?

4. For an overall sharpening, set the Radius to 1 pixel and the Amount to 100%. Under the Remove menu, choose Lens Blur. The choices there may seem oddly named, but Lens Blur is the choice for pictures that were taken with good camera techniques. Radius and Amount settings are somewhat dependent on file size and image content. The radius determines the spread of the sharpening along detected edges. Experiment with different settings and see how they look.

5. Click OK.

6. If specific tonal areas seem to need more sharpening, open the Smart Sharpen filter again.

7. Click on the Advanced button, and then on the Highlight or Shadow tab. Those tabs let you limit sharpening to their corresponding tonal areas.

8. For example, let's say our famous picket fence needs more sharpening—after all a picket fence should look sharp. Click on the Highlight tab, then if there is a wide tonal range you want to affect, set the Tonal Width at a fairly high value (e.g. 60%). Set it lower (say 20%) if the tonal range, like that of our picket fence, is narrower. Next set the Radius to 1. If that effect looks too much, reduce it by increasing the Fade Amount, which reduces the degree of sharpening.

9. Repeat step 7 if you want to sharpen shadow areas.

10. Click OK.

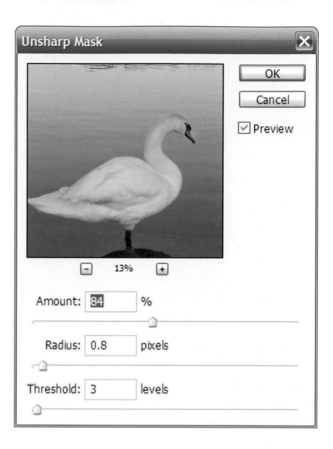

Using Unsharp Mask

Long the sharpening tool of choice, Unsharp Mask (USM) remains an effective tool to increase the sharpness of your digital photos. Here's how you can apply USM:

1. Save your layered image file.

2. Now flatten the image (Layer>Flatten Image) and save it under a new file name so you don't accidentally replace all the hard work in your layered file. Go to Filter>Sharpen>Unsharp Mask. Check on the Preview box. If you want to use a layer to do the sharpening, create one by pressing Cntrl/Command J.

3. Try one of the setting combinations from the table (below left) for the picture you are shooting. Again, vary settings to match the content and feeling you're trying to create. For file sizes smaller than 10 MB, you should reduce the Amount and Radius settings by about 25%.

4. If the effect seems excessive, you can always undo the sharpening action and redo it using reduced settings. But you can also fade the effect. Go to Edit>Fade Unsharp Mask, and reduce the effect until you like it. Or if you did the sharpening on a layer, you can reduce the opacity of that layer. Some people also like to change the blending mode to Luminosity to try and reduce the color halos that sometimes appear from over sharpening.

5. Click OK

Unsharp Mask Settings

Subject	Amount	Radius	Threshold
General sharpening	125	1	2
Female Portrait	100	0.6	8
Male Portrait	125	1	4
Powerful landscape	140	1.3	2
Soft landscape	100	0.8	4
Action/Sports	150	1.3	1

Setup for Shooting Panoramas

Here's how to take the picture.

1. Look over the scene and consider the composition you want for the panorama.

2. Put the camera on the tripod (position the camera vertically if you want the image to have more height) and roughly simulate the series of pictures you will take. Keep the camera level, not pointing up or down by more than a few degrees. Since you need to overlap each succeeding picture with its predecessor, consider what you will use as marks to establish that overlapping area. Pan the horizon from left to right as a test. If I am doing a lot of panoramas, I like to shoot a frame before and after the sequence with the lens cap on. This helps when I get back to the computer because I can see where the sequences are.

3. Set the camera to Manual exposure mode, manual focus, and manual white balance. Set the aperture to provide the appropriate depth of field. Now set the shutter speed to provide good exposure. Take a picture and look at the histogram to see if it's meeting your exposure needs. If you need to change exposure, it's better to change the shutter speed. (Do not use a polarizing filter because the effect varies across the sky, causing unnatural darkening and lightening.)

4. Focus the camera, and keep the same focus position throughout the series.

5. I suggest you work from left to right. Take the first picture. Find a branch, hill, building or something about 1/5 of the way into the picture from the right side of the viewfinder frame. You will align the next picture to this landmark.

6. Pan the camera clockwise until the landmark you found is about 20 percent from the left side of the frame. This creates your overlap.

7. Take picture two in the sequence.

8. Follow steps five and six for each picture you take in the sequence, being sure to overlap each frame about 20% with the previous frame.

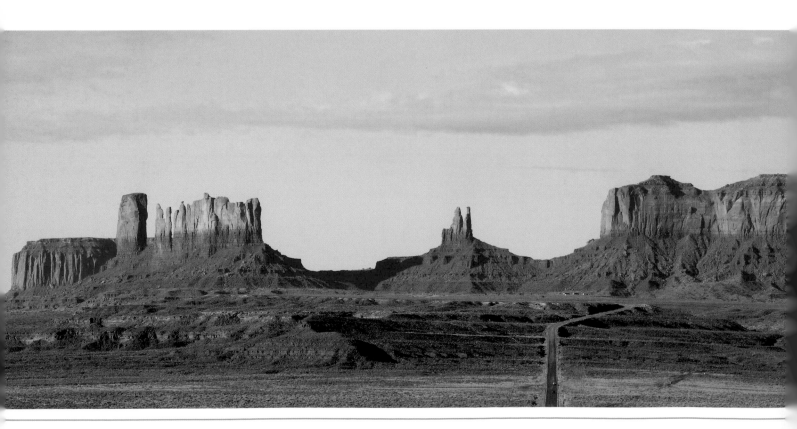

Merging Your Photos

Here's how to combine the pictures in Photoshop CS3. CS2 is similar but offers fewer options in the Photomerge window.

1. Go to File > Automate > Photomerge.

2. In the Photomerge window for CS3, you have several choices to make:

For Layout, choose one of the following:

- **Auto:** Photoshop automatically applyies a Perspective or Cylindrical effect, and works well for simple 3-shot panoramas.

- **Perspective:** Using the middle image as the base to match, this stretches or skews the other images so they fit with the middle image.

- **Cylindrical:** Best for wide panoramas. Reduces the bowing effect.

- **Reposition Only:** Aligns the overlapping images without making any other changes.

- **Interactive Layout:** For manually positioning images.

3. Check the Advanced Blending box.

4. Choose your source files from the Use drop-down menu. (If you have a folder with only the panorama files in, choose Folder. Otherwise choose Files.) Then click the Browse button to find and select the appropriate choice. Click Open.

5. If in CS3, click the checkbox for "Attempt to Automatically Arrange Source Images."

6. Merge the files.

The proof is in the print. Now that you have worked to create a high-quality image file, you're ready to take the next step and print it. This is the final and definitive stage in the process of creating an ultimate photograph.

How to Make an Ultimate Print

Photo © Gary Whelpley

Start by setting up Photoshop correctly for printing, deciding whether to let Photoshop (my choice) or the printer driver handle the color. Remember that the last adjustment steps before printing should be resizing and sharpening your image.

The overview steps for proofing and printing:

1. Become familiar with your printer.

2. Profile your printer with two favorite papers to get high quality prints faster.

3. Set your print driver correctly for the paper used.

4. Refine contrast, color, and sharpness of your photo file to optimize it for printing.

5. In Photoshop, use View>Proof to approximate on screen what the picture will look like on paper.

6. To maximize detail, print without interpolating the file.

7. Make and evaluate test prints at your printer's highest and next highest dpi settings.

8. View proof prints in appropriate lighting.

The Great Compression

From taking the picture to adjusting and printing it, the goal is to maximize and preserve dynamic range, tonality, color, and sharpness. In the real scene, the dynamic range or brightness ratio from the brightest subject to the darkest could easily be 10,000:1, or even 100,000:1. But the camera's sensor reduces that ratio between brightest and darkest to less than 1000:1. Now, with your printer, you're about to further compress that once huge brightness range into a print that has a ratio of only about 100:1.

An impossible challenge? So the math would seem to indicate. But you've seen beautiful photographs all your life, and you know a print can indeed represent the wonders and variables of light. The question becomes how do you match the exquisite prints you've seen on gallery walls?

Should you make prints yourself or use a professional lab? If you establish a relationship with a lab you may be able to ask questions and tap into their expertise. Photo © Gary Whelpley

Print Your Own or Use a Lab?

Your first decision is whether to do it yourself or hand it off. Is it heresy to give your files to a lab for printing? For in the world of "real" photographers, printing is how you close the creative circle. Yet if you print your own pictures, you face a whole new gauntlet of challenges. On the other hand, if you give your files to a lab, then your work is done. You can go back to taking pictures.

Let's face it. Printing your own pictures takes time and money. And making good prints requires a high level of expertise. It seems to make good sense to just hand off files to a professional lab that prints photos every day. These pros know what they are doing and have rooms full of equipment and staff to calibrate, profile, tweak, and routinely transform files into beautiful prints. After all, once you've refined and polished the file, haven't you completed your vision? The lab need only remain faithful to the file you created.

To use a lab or make your own prints becomes a personal decision. You can always audition a printing lab if you are cautious about handing your files over for printing. If you're uncertain about the quality of prints you can make yourself, you may also want to audition yourself. Make your best print of a picture and then send the same file to a lab (or several) and see who does better.

Audition a Lab

How do you choose a lab? Give two, three, maybe even four labs the same file and ask for an 8 x 10 inch print (20.3 x 25.4 cm). Try to include a couple of local labs, because face-to-face communication builds relationships, which usually improves service and print quality. Here are some questions to ask.

- Does the lab handle a lot of images similar to yours?

- Does the lab accept Photoshop (PSD) or TIFF files, or only JPEGs?

- How do they want the images delivered: CD, ftp, proprietary upload, email?

- Will the lab adjust any shortcomings it finds in your files?

- Does the lab show proofs of work?

- Will they match a color print you send with the order?

- Do they offer printer profiles you can incorporate?

- Will the lab redo prints with which you're dissatisfied?

- Can you have a personal conversation with the lab about your image needs?

- Does the lab offer the type of paper you prefer?

- And, of course, what's the cost?

Not all the questions are equally important, and you decide which take priority. In the end, isn't it enough if the lab delivers superior prints? After all, quality reigns supreme. It's unlikely you will be able to discuss your photos with a big lab and get them to custom print your pictures. That wouldn't be cost effective (or it would be very expensive) because they handle thousands of images each day. You shouldn't expect a lab that specializes in portraits or wedding photography to excel at printing butterflies.

Silver Halide or Inkjet Paper?

Many labs let you choose from silver halide or inkjet paper. Silver halide is the traditional paper long used by film photographers. It's been re-engineered to make superb prints from digital files using printers designed for this purpose. It offers longevity comparable to inkjet technology and is truly continuous tone since it does not use dots like inkjet printers. It's often cheaper. Perhaps the biggest disadvantage of silver halide is the small selection of paper surfaces compared to the much wider variety of surfaces found in inkjet papers. However, if you're framing the picture and using glass, the glass tends to disguise the effect of paper surface.

For photos of memories you want to keep a long time, you're best off using inks and papers from the maker of your printer.

Print Longevity

As a serious photographer you want your prints to last. But "how long?" is not an easy question. Longevity is dependent on three basic factors: paper, paper-ink combinations, and proper storage. In inkjet printing, it's hard to separate paper and inks. Archival papers are acid and lignin free. Cotton rag papers are known for being archival, but other papers properly manufactured can also be archival. Archival paper doesn't yellow or become brittle; it endures over time in its original condition.

So archival papers are good, but part of the equation for longevity is the interaction between paper and ink, and equally important, the ink-paper-environment interaction. The printer manufacturers scientifically engineer their paper and ink combinations to work together to maximize print life. Many papers are designed to protect their inks from environmental conditions, such as ozone and pollutants. Pigment inks tend to better resist fading due to light than dye inks, but are more susceptible to gases.

Photos courtesy of Epson America, Inc.

It's up to you to research this fast-changing technology to make sure the paper/ink combinations you use will meet your longevity goals for prints. www.wilhelm-research.com is the testing company used by many printer manufacturers to support their longevity claims, so you can find information on HP, Epson, Canon, and others at the site. They review some independent papers, but you may need to do additional research to find out about the longevity of these independents.

Proper storage is also important to prolong the life of a print. Good storage practices include the use of acid-free boxes or other containers made specifically for storing prints. Simply placing the prints in the dark extends longevity by minimizing fading due to light. To further increase print life, store the container in a fairly dry (30-50% humidity) area away from gaseous pollutants (ozone is a notorious offender).

Photo Papers

As an ultimate digital printer, you should limit your core printing to two or three papers appropriate for your mainstream subjects. Typically, a luster or glossy paper, plus a fine art paper and a matte paper, will cover 80% of your needs. By limiting your paper use, you get to know these papers and fine-tune your system and adjustments accordingly. However, it is still a good idea to experiment with different papers in search of ones that better meet your creative needs.

When it comes to papers offered by printer manufacturers, Epson has significantly more choices than Hewlett-Packard, and HP more than Canon. But your choices expand dramatically when you include third-party providers who make papers for a wide variety of printers. If you opt for a third-party paper, consider two issues: (1) possible reduction of print longevity; and (2), accurate colors may be more difficult to achieve (unless the paper manufacturer provides a profile you can load and use). Profiles for papers from your printer manufacturer are usually built into the print driver and can be invoked via Photoshop or your printer.

Printer manufacturers naturally try to convince you to use their paper-ink combinations. They stress that you will get superior quality with their products because these components are designed to exploit the capabilities of each other. They also like to claim that photographs represent your family's legacy, and you can therefore live into posterity through your photographs–but only if the photographs outlive you.

It may be best to take such claims with a grain of salt. Many of these providers actually outsource the manufacture of papers, while a number of third-party suppliers now offer papers with similar longevity claims, though at present you should realize that nobody backs up all this science with a meaningful guarantee. The best bet, when longevity is paramount, is to use the color inks from your printer manufacturer, and use papers that you are confident will meet your longevity needs (probably from your printer's manufacturer).

Choose a paper surface that's appropriate for the subject of your photograph. Matte papers are a good choice for landscapes. Experiment with a textured surface if you want to emulate a painting.

Types of Papers

Despite the importance of becoming familiar with a few core papers, it is wise to try different papers from time to time in order to extend your personal vision. So keep a packet or two of specialty or fine-art papers on hand to experiment and test when you have time.

The type of printer you own largely determines the general category of paper you should use. The two primary categories for printer papers are microporous and swellable, which is also called polymer. (Cotton rag papers could be considered a third category and are often preferred by fine-art photographers for their inherent archival qualities.) Microporous papers are commonly used with pigmented inks. A surface coating creates millions of nooks and crannies that form a network of microscopic pores that capture and hold the ink.

You can identify microporous papers by touch. When you run your finger across their surface, they squeak and seem to grab at your skin—a sensation caused by their rapid absorption of the oils on your finger. Microporous papers dry almost immediately, avoiding the "dry down" effect common with swellable papers that leaves prints slightly wet as they emerge from the printer, often appearing darker several hours later when they are fully dry. The quick-drying microporous papers, however, look nearly the same when emerging from the printer as they will hours later, which is an advantage because you can evaluate the print and adjust the file with confidence that the colors will not change over time.

Swellable papers are most often used with dye-based inks. Since these papers use plasticizers, their structures resemble traditional photo papers. Ink is absorbed at a slower rate than with microporous papers. The polymers surround the ink, sealing it off from direct exposure to the air and ozone, thus reducing fading. Because the ink dries slowly, swellable papers require careful handling, including air-drying overnight before framing behind glass.

Here are three main questions to ask yourself when choosing a paper:

• Is it compatible with your printer (microporous for pigmented inks, swellable for dye inks)?

• Do you like how your pictures look on it?

• Does its longevity meet your needs?

Choosing can be that simple. Pictures are all about appearance. From the variety of papers and surfaces available, you can find a few to give your pictures the look you want.

Characteristics of Photo Paper

The four primary characteristics are weight, thickness, whiteness, and surface. Weight and thickness most affect how a print feels in your hands and have an impact on durability through the paper's ability to withstand wear and tear. Whiteness and surface texture most affect the appearance of a print.

• **Weight:** This characteristic is typically expressed in pounds (lb) or grams per square meter (gsm), and is usually a bulk weight (not per individual sheet). Added factors, such as clay coatings, polymers, and thickness contribute to a paper's weight. A heavier paper may feel more luxurious and have greater durability than lighter sheets, but the weight is not particularly important in and of itself.

• **Thickness:** A sheet's thickness is defined in thousandths of an inch, or mils. Standard photo papers are 9 to 10 mils thick. A thick paper is sumptuous to touch and feel. And its extra stiffness often increases its durability by resisting dings and creases from careless handling. However, thick papers can jam your printer, sometimes because the path requires the paper to bend. Finally, the importance of thickness disappears if the print is mounted

• **Whiteness:** Defined by ISO (International Organization for Standardization), paper whiteness has a top possible rating of 100. Normal glossy photo papers have a whiteness rating of 90–95, which means they're very white, probably due to an optical brightener, which could raise concerns over longevity (the paper could yellow when the brighteners break up).

A bright white paper is highly reflective and should excel in revealing vibrant, rich colors. A truly neutral white paper is indeed white, not slightly blue or yellow. The more neutral its whiteness, the more accurately the paper can reproduce those colors you've worked so hard to adjust. However, superior accuracy doesn't always equate to superior attractiveness. It is always possible that you prefer a cooler or warmer paper as an aesthetic choice.

• **Surface:** The characteristic that most affects your photo's appearance is paper surface. It can vary from super smooth to textured to rough. Photo paper surfaces tend to fall into three categories based on how much light they reflect: glossy, matte, and textured.

The term glossy covers several categories, each respectively a bit less reflective and shiny: glossy, semigloss, luster, pearl, and satin. Except for glossy, the other terms are often interchangeable among the different manufacturers: One company's semi-gloss paper may look like another's luster. Matte papers often include papers with other names, such as watercolor, velvet, and smooth. They are neither shiny nor highly reflective. They can be quite white. And papers with textures can emulate canvas and linen cloth surfaces.

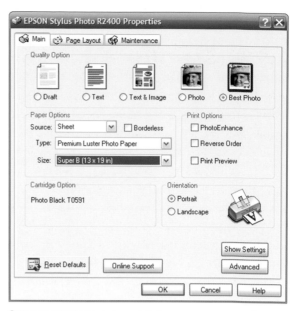

Set your printer driver to match the paper you are using.

Matching Paper to Subject

Choosing a paper is a personal and subjective decision, though selecting a surface compatible or appropriate for your subject matter may be your most important paper decision. Papers can either complement a subject or detract from it. The interaction between paper and ink, in many cases, will determine whether you like your photo's appearance and whether that paper is well suited for your type of photography.

- **Glossy and Luster Papers:** The bright, smooth surfaces of glossy, semi-gloss, and luster papers excel in revealing the full range of tonality, the wide spectrum of color characteristics, and minute details. Only a gloss-type or luster paper can exploit all these characteristics, and only a glossy paper can give you a deep, dark black, along with a bright white. But the shine and glare of glossy papers can detract from your display. And pigment inks printed on glossy paper can result in a differential gloss, often called bronzing, which can make the surface look flawed. For that reason, many photographers prefer a luster or semi-gloss paper. These are basically glossy papers with a bit of a texture or pattern, often called an orange peel effect. They may not quite match a glossy paper in revealing tonality, color range, and sharpness, but they come close. If you want to almost feel the texture on a butterfly's wing, be dazzled by the sparkling of stream or waterfall, or overwhelmed by a brilliant sunset, consider one of these papers.

- **Matte Papers:** Matte papers are quiet. They reveal the best qualities (and subdue some of the flaws) of your subject without shouting. Reduced reflections make it easier to see the subject from any angle and eliminate the differential gloss of pigmented inks printed on a glossy paper. The lower level of reflection reduces contrast, brightness, and color brilliance–all benefits if you match the matte surface to the right subject–but not right for all subjects. Matte papers work well to create a quiet, classic mood, often well suited for portraits, still-lifes, and landscapes. Many fine-art photographers use them for gallery exhibitions. However, when mounted and framed under glass, the surface differences of glossy and matte papers become less noticeable.

- **Textured Papers:** Textured papers include linen and canvas textures. These surfaces don't show as much detail as others, but do convey mood and emotion, so match them to appropriate subjects (they are often used for portraits). Make sure your printer can handle these and check the paper manufacturer's fact sheets for any post printing treatments to help preserve and protect them. Some textured and cotton papers shed paper fibers that can clog printer heads or paper feeding mechanisms.

Preparations for Printing Ultimate Photos

It's easy to knock off a fast print. It's another matter to create a print that will stay true to the exquisite file you have created: Wide dynamic range, neutral highlights and shadows, smooth midtones, accurate colors throughout, and razor sharp details. You achieved this by methodically taking a picture using ultimate techniques at every step: a sharp lens set at its best aperture, a low ISO, precise exposure using the RAW file format with the camera on a tripod. You then carefully adjusted the image in 16-bit mode to maximize data while viewing it on a calibrated monitor to maintain color fidelity. Now the file is ready for printing.

At this point, you should find out if your printer can support 16-bit files. If it does, you may want to use it to derive every extra bit of quality from your print. However, the visual difference in prints is often minimal between a 16-bit and 8-bit file, and the smaller size will print faster. Of course, if your printer does not support 16-bit, you will have to convert the image file to 8-bit mode (Image>Mode>8 Bits/Channel).

Let's continue the methodical approach in testing and setting up the printer, finalizing adjustments, and then testing and making the print.

Setting Pixels Per Inch (PPI)

Though the camera captures the detail in your photo, it's the printer that reveals this detail when you transform the picture to printed format. How big you can make a print and still maintain detail depends on the size of the camera file used for capture and the resulting image file after processing. If quality is not an issue, you can make a print of any size. But the first step in preserving quality is to keep the original pixels in the file without altering them–in other words, don't add to or subtract from them. You want to avoid interpolating when resizing the picture.

Note: Interpolation is a mathematical process that changes the number of pixels in a picture. When determining the print size in Photoshop, you have to uncheck the Resample Image box so you do not interpolate, or resample. Unchecking this box will ensure using the available pixels without change.

Megapixels / Print Sizes

Camera Sensor MP	Maximum Print 240 ppi		Maximum Print 300 ppi	
	inches	cm	inches	cm
6	8.3 x 12.5	21.1 x 31.8	6.7 x 10	17 x 25.4
8	9.7 x 14.6	24.6 x 37.1	7.8 x 11.7	19.8 x 29.7
10	10.8 x 16.1	27.4 x 40.9	8.6 x 12.9	21.8 x 32.8
12	12.5 x 16.7	31.8 x 42.4	10.0 x 13.0	25.4 x 33.0
16.7	13.9 x 20.8	35.3 x 52.8	11 x 16.6	27.9 x 42.2

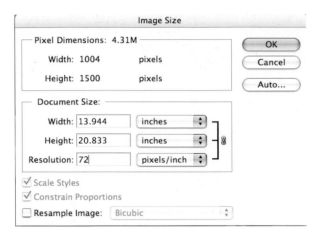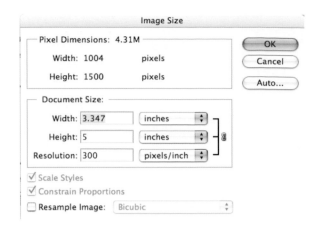

If you uncheck the Resample Image box (lower left corner), changing the resolution value will alter the document dimensions but keep the pixel dimensions (file size) the same.

But let's back up for a moment. The metric for converting the camera file to print dimensions is pixels per inch (ppi). When you open a camera's file in Photoshop, its resolution is expressed in ppi. When you take a picture, it is recorded at its native resolution—the number of pixels that the sensor can hold. You can see the resolution of your picture at any time in Photoshop by opening the Image Size window (Image>Image Size), or by Alt/Opt clicking on the file size value in the status bar at the bottom of the image. You will also use the Image Size window to determine print size, using the Document Size fields.

Note: When you open the Image Size window, don't be surprised if you see a default value of 72 appearing in the ppi box. If you do, you'll also notice that the document size is likely huge–30 or 40 inches (76.2 or 101.6 cm). Don't worry, you can change the value in the ppi field to a more appropriate printing resolution of 240 or 300, and watch as the document dimensions shrink to a more normal print size.

If this is somewhat confusing, you'll understand it more easily by opening the Image Size window in Photoshop and experimenting with the values. First, uncheck the Resample Image box. Now type in different print-size dimensions while keeping your eye on the ppi value. When you input larger print dimensions, the ppi value decreases. When you type in smaller print dimensions, the ppi value increases. What does not change (as long

as the Resample Image box is unchecked) is the total number of pixels. But if you now check the Resample Image box, and then type in new print dimensions, you'll see the number of pixels in the file change. That means you are asking Photoshop to create more or fewer pixels.

When Photoshop alters the pixel structure in this way, quality will be lost, most noticeably when you increase the number of pixels in order to make a bigger print. The program makes an "intelligent" approximation about how to create those added pixels by using mathematical formulas that look at existing pixel information before producing and inserting the new ones. But those new ones weren't created by the camera; they weren't part of the actual scene. So some of those new pixels will not fit well into your picture, no matter how good the equation. Interpolation isn't perfect.

In general, your goal is to maintain print size at a level that uses only the original pixels in the file. Sometimes you will find that setting up a best-quality print means you end up with a value like 400 or 500 ppi. This is an example of when you might as well resample the picture to a smaller file size, eliminating pixels, because you're not likely to notice the difference in detail above 300 ppi.

Setting Printer's Dots Per Inch (DPI)

Once you determine pixels per inch in your image file, you should determine dots per inch (dpi), which is a setting in your inkjet printer that controls the quantity of ink dots the printer puts down on its medium. This is fairly easy to do because it's a predetermined choice of settings in the print driver. Most printers offer typical settings of 1440 or 2880 dpi, suitable for high quality photos, although some may go even higher. Not all printers express the dpi in the dialog window as a numerical value. For example, Epson uses the terminology "Best Photo" and "Photo RPM" (oddly enough Best Photo isn't best, Photo RPM is).

A print consists of millions of precisely placed tiny colored droplets of ink. It would seem obvious that using 2880 dots per inch would reveal more detail than 1440 dots per inch. But even at 1440 dpi, the dots are so small and the printer so cleverly arranges them that you may not be able to see the difference. Since ppi and dpi together determine how much detail a print reveals, you should test with your printer to see if using the highest dpi setting is always necessary. If you can't see the difference in prints between the highest and next highest values, why bother using the highest dpi setting? It will slow down your printer and use more ink.

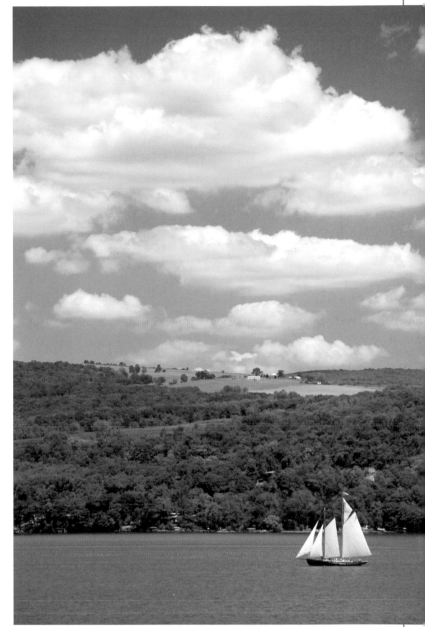

You may not have to set your printer to its highest dpi for excellent prints. Often the "next best" option saves you ink and still produces outstanding results.

Print	PPI Setting	Printer Driver Setting *
1	240	Second highest quality setting (often 1440 dpi)
2	240	Highest quality setting (often 2880 dpi)
3	360	Second highest quality setting (often 1440 dpi)
4	360	Highest quality setting

*Some printers don't list dpi numerically, but may use a word description. On the R2400 and R1800 models, Epson uses "Best Photo" to indicate the second best quality and "Photo RPM" to indicate the best quality.

Test to Determine Print Quality

Because you want to understand the capabilities of your equipment, you should conduct a test to determine the combination of image and printer settings that gives you the most meaningful results. In Photoshop, open a good picture with areas of fine detail and some continuous uniform tones, such as a face or blue sky. Make four 8 x 10 inch prints (20.3 x 25.4 cm), using the specs in the table above. On the back edge of each print, write the values used to create it. When you've printed all four versions, look at the prints side by side at arm's length, and then up close, to see if you notice any meaningful differences. You may want to invite an additional person to view them to get a more objective opinion.

The bigger the print, the farther back you stand to view it; and the farther away you stand, the less detail you can see. This suggests that you can reduce an image's ppi as it is printed larger. But as an ultimate photographer and printer, you want to be careful about making prints at a reduced ppi, even large ones. For a 13 x 19 inch print (33 x 48.3 cm), try to use 240–300 ppi.

What native camera resolution is required for a 13 x 19 print at 240 ppi? Look at the table on page 133 to see maximum print sizes according to a camera's sensor size in megapixels. This is without any cropping.

Interpolating a file to make a bigger print alters the pixels.
Some subjects fare better with interpolation than others.
Photo © Gary Whelpley

Changing Image Size with Interpolation

There are two reasons to use interpolation to change image size: (1) to create more pixels so you can make a bigger print; and (2) to reduce pixels so you can reduce file size and make a smaller print more quickly.

Note from the table on page 133, a camera with an 8MP sensor using native resolution can produce a print of 7.8 x 11.7 inches (19.8 x 29.7cm) at 300 ppi. Therefore, to increase print size to 11 x 14 inches (27.9 x 35.6 cm) or larger and retain 300 ppi, Photoshop must interpolate upward, which requires the creation of new pixels. Some companies offer products that claim to do a better job than Photoshop at creating these new pixels. Regardless of the program, the new pixels are never as good as having original pixels, so creating big prints from interpolated files can never equal the quality of a picture made solely from original pixels

If you resize in Photoshop, set the drop-down menu at the bottom of the Image Size dialog window to Bicubic Smoother when resizing upward, and to Bicubic Sharper when resizing downward. You will likely need to sharpen the image after interpolation. Reducing downwards isn't much of an issue, but going up by 100% is probably the maximum you can do and still keep the quality reasonably high. This is somewhat subjective. You'll find some subjects lend themselves to interpolation and can be blown up fairly big, while others show quality problems with even a modest interpolation increase. It's one of those things you have to try and see for yourself.

A small test print lets you quickly evaluate color, contrast, and brightness. Photo © Gary Whelpley

Adjustments

You're about ready to produce an ultimate print. You've shot a good picture, adjusted the image file to get the best out of it, and selected high-quality photo paper and ink. Now you will make a test or proof print to evaluate the photo and determine how to tweak adjustments to the file so it looks great as a final print. This may require a few cycles of adjusting and proof printing, and then finalizing the file by resizing and sharpening. And then you'll review your printer setup so it's ready to make that ultimate print.

Making Proof Prints

When should you make a proof print? I usually make one at two stages. The first stage is before I make final adjustments, so I can get a feel for how the picture will print; the second is after final adjustments, to make sure it prints the way I want. Seeing a picture on paper is so different than seeing it on a monitor that I don't begin to feel comfortable with a photo until it's in my hands.

So before I start refining the image, I quickly make a test print of 5 x 7 inches (12.7 x 17.8 cm) with the

paper I plan to use for the final print. Print size does have an impact on perception, so printing smaller may not be a reliable test of how your final print will look, but it does give you a good feel for color, brightness, contrast, and overall balance. In his fine-art printing book, George DeWolfe makes a good point about viewing and adjusting the image using Photoshop's proofing mode (View>Proof Setup) because it is the only way you can see on a monitor what the impact of specific paper will be on the appearance of your print. If you don't use this setting when making adjustments, you'll likely have to make added changes because the actual proof print may vary quite a bit from the unproofed image on the monitor.

In any event, give his suggestion a try to see how much the simulated proof varies from the standard monitor display of your photo. In Photoshop, go to View>Proof Setup>Custom, and choose your paper from the drop-down menu. If you don't see your paper in the Device to Simulate menu list, then you likely don't have a profile of it on your computer. Click on the Simulate Paper Color box to see the display change as it tries to simulate how the picture will appear when printed. Then make the settings and print the proof: In the printer driver, choose the paper size and dpi (or the high photo quality setting if a numerical dpi value isn't offered).

Evaluating a Proof Print

Make sure your first proof print is dry, then take it to a viewing area and look it over. Once you've formed impressions, take a Sharpie and mark the issues you want to address right on the print. Then use the marked-up proof to guide you in adjusting the file for final printing. As you review the print, consider the following:

• Glance at it from arm's length and get a quick general impression. Does it do justice to the photo that's in your head?

• Does the photo represent and emphasize the subject as you intended?

Mark up your proof prints so you have a record of changes you made.

add color to water

darken sky bring out color

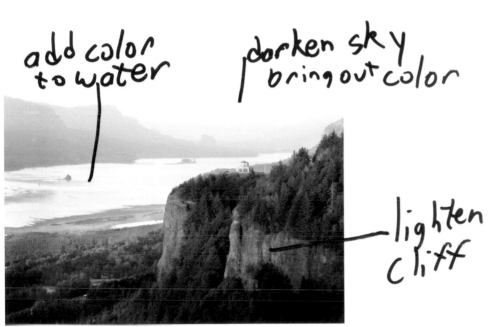

lighten cliff

- Are you using the right paper? Does it work with the subject matter?

- Evaluate the proof for more specific photo qualities: How is the overall color? Is it appealing? Does it approximate the image you adjusted on the monitor? Are the neutrals neutral and the memory colors (foliage, flesh, skies) good?

- How is the tonality? Do highlights and shadows reveal details? Are contrast and brightness appealing and appropriate for the subject?

- Do any flaws remain: excessive noise, spots?

- Are there any printing issues such as banding/streaking in uniform midtones?

Also evaluate to see if there are local areas of the image that should be fine-tuned. Sometimes adding a deep black or bright white to a small area can intensify the entire image. And darkening or lightening certain parts can properly accentuate or subdue picture components for proper emphasis. Similarly, sharpening or saturating specific parts or details of a photo can make it sing.

Minor adjustments were made to the original file (top) resulting in a more natural color (by reducing the blue) while tweaking contrast and maintaining the bright orange of the goose's bill and feet (bottom).

Fine-Tuning Brightness, Color, Saturation, and Shadow/Highlights

You made major adjustments to your photo while working on the RAW file earlier. So your photo should be in pretty good overall shape. Now, with a proof print marked to indicate fine-tuning adjustments, let's tweak it for final printing.

Now we are dealing with overall adjustments that will change the entire image. Make these changes using layers so you can undo or revise them without starting over. Here are the final overall adjustments to refine (but only if needed) before printing.

Brightness/Contrast

1. Click on the half moon at the bottom of the Layers palette and open a Levels layer.

2. Refer to your proof print and tweak adjustments as needed. To verify brightness values of a particular area, mouse over it and look at the values displayed in the info window (Window>Info).

3. Adjust the opacity level in the Layers palette to reduce the effect as needed.

4. Rename the layer: Double click the text in the layer bar and type in the name BrightnessContrast.

Color Balance

1. Click on the half moon at the bottom of the Layers palette and open a Color Balance layer (or a Curves layer if you're comfortable with the finer control this tool offers).

3. Adjust the opacity level in the Layers palette to reduce the effect as needed.

2. Refer to your proof print and tweak adjustments as needed. To verify color (RGB) values of a particular area, mouse over it and look at the values displayed in the info window (Window>Info).

Color Saturation

1. Click on the half moon at the bottom of the Layers palette and open up a Hue-Saturation layer.

2. Refer to your proof print and adjust as needed (but be gentle, particularly if you're boosting saturation). If the whole picture needs more saturation, drag the Saturation slider to the right. Usually, you're better off adjusting specific colors: In the Hue/Saturation window, click on Edit and select the colors individually to adjust, then drag the Saturation slider right to increase, left to decrease saturation.

3. Rename the layer: Double click the text in the layer bar and type in the name Saturation.

Shadow/Highlight

The ease of using the Shadow/Highlight tool cannot be denied. When used in Photoshop Camera Raw, it doesn't actually alter the pixel data. However, be careful of overdoing it because the effects can seem odd looking.

1. Select the Background layer in the Layer palette

2. Press Cntrl/Cmnd J to create a new background layer.

3. Go to Image>Adjustments> Shadow/Highlight.

4. Tweak the tools to achieve the effect you want. If you have to do more than minor adjusting, consider reworking the image in Camera Raw to avoid doing it here.

5. Rename the layer: Double click the text in the layer bar and type in the name Shadows-highlights.

Shadows/Highlights

Shadows

Amount: 0 %

Tonal Width: 50 %

Radius: 30 px

OK

Cancel

Load...

Save...

☑ Preview

Highlights

Amount: 34 %

Tonal Width: 11 %

Radius: 30 px

Adjustments

Color Correction: +20

Midtone Contrast: 0

Black Clip: 0.01 %

White Clip: 0.01 %

Save As Defaults

☑ Show More Options

Save Your File

As you work on your file, periodically save it as a layered PSD so you can easily recover it should anything happen. You may want to put it in a dedicated folder for print work that's in progress.

The sunlit area was originally too light (top). It was darkened to look more natural by using the burning technique, and the shadow was lightly dodged to reveal more detail (bottom).

Selective Adjustments

As you did when first making your adjustments after importing your RAW file to Photoshop, you can fine-tune selected portions of the image. After you have made adjustments to the overall image, you might want to brighten a face, sharpen a rose bud, or darken a particular shadow. Use Photoshop's selection tools to add (or subtract) emphasis, reveal detail, or make minor changes to enhance the photos. See page 116 to review the Photoshop techniques for selective adjustments

Dodge and Burn

Dodging (lightening) and burning (darkening) are traditional darkroom concepts that remain as valid as ever. By dodging and burning selective areas, you can focus the attention of people who view your photo to those areas you want to emphasize. You can also accentuate or subdue texture and form.

However, you must be careful. The Dodge and Burn choices in Photoshop's toolbox directly alter pixels and are suitable only for moderate adjustments in fairly small areas.

Here's a better alternative to the dodging and burning tools:

1. Create a new background layer by dragging the background layer onto the new layer icon.

2. Set the layer blending mode to Soft Light and the Opacity to about 25%.

3. Set the foreground color to black to darken an area or to white to lighten it.

4. Choose the brush tool and set its size: on keyboard, press the left bracket (next to P key) to reduce brush size, press the right bracket to increase brush size.

5. Set a soft brush (hold the shift key and press the left bracket to soften the brush, the right bracket to harden the brush).

6. Now sweep the brush over the areas you want to lighten or darken.

7. How's it look? If it's not what you want, alter the opacity setting.

8. Rename the layer: Double click the text in the layer bar and type in the name Dodging-Burning.

Examine your photo closely to see if any small adjustments will make a big difference in its final appearance.

The Final Steps

Enlarge the image to 100% and inspect it one last time. Did you get rid of all the small dust spots, facial blemishes, litter in the foreground, excessive noise, and other distracting faults in the photo? Once you are satisfied, set the size for printing:

1. Open the Image Size dialog box (Image>Image Size).

2. Uncheck the Resample Size box at the bottom left.

3. In the Document Size part of the box, type in the width and height of your print. Check that the resolution meets your needs (minimum of 220 to 360 ppi for prints whose longest dimension is 14 inches). Click OK.

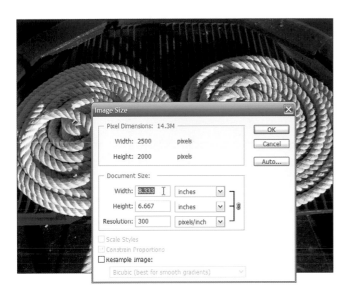

4. Type in a resolution value, typically from 240 to 300.

5. Save the file.

Now is the time for an overall sharpening if you think it is needed. After flattening the layers on which you've been working, create a new layer for final sharpening. See pages 119-121 to review the final steps you will make to sharpen the image. But use care not to over-sharpen. You have used the Smart Sharpening or Unsharp Mask tools previously to enhance your image, so you will want to be as restrained as possible at this stage of the process.

Make Another Proof Print

You're nearing the finish line. Once you have applied any necessary sharpening, make another proof print and evaluate it as before. How many proofs will you need to make before one meets your approval? Fewer as you become more experienced. But even skilled printmakers, or should I say especially skilled printmakers, expect to print and improve adjustments several times before achieving a print that agrees with their perfectionist eye. So making three to five proof prints would be fairly normal.

The final step is to sharpen on a duplicate layer. It is important not to oversharpen because that can degrade the quality of your ultimate image.

You can evaluate prints by indirect natural light (above) or with an inexpensive, full spectrum Ott light (opposite page). Photo © Gary Whelpley

The Lighting Environment

In what light should you examine your proof prints? This can be an easy answer or a tricky one. Professional photo labs use a professional viewing station with full spectrum lights housed either in a room or large viewing box with neutral gray walls. For years the standard viewing temperature has been 5000K (slightly warm daylight). But with LCD monitors taking over, the industry is moving to lights with the somewhat cooler temperature of 6500K because they more closely match LCD monitors. By using a standard viewing light, labs eliminate one extra variable (color temperatures) in their print making process. That should be your goal

Photo © Gary Whelpley

To be honest, many of us when making our own prints simply look at the picture under room light, which is not the greatest practice to achieve our goal of creating the ultimate photo. I suggest that the best alternative in such a poor viewing environment would be to use indirect window light. Stand a few feet from a window (no direct sunlight) and study the print. On a lightly overcast day, the color temperature of indirect window light is close to 6500K. The problem, of course, is consistency, because few of us live in an area that is continually cloudy (although I'm one who does). And naturally, the time of day and type of clouds will also alter the temperature of light coming through your window. You should avoid fluorescent lights and the light from incandescent lamps, unless those illuminate the environment in which you will display your photo. As a test, you might want to take a favorite print and view it under each of these types of lighting and see how different it looks

The Ott-lite is a relatively inexpensive full-spectrum lamp that could meet your needs. You'll want to consider how your print will look if hung on a wall where the lighting is different than a full-spectrum, 6500K viewing light. The print could appear too dark, perhaps flat, or even have a color cast. It's not necessarily the print that is less than optimal, but the environmental lighting that strikes the picture. If you view your proof under a bright, full-spectrum light, and then hang the print on a wall illuminated by diffuse window light (7000-8000K), the picture may seem dark and bluish. If you actually know where you are going to hang the print, consider taking the proof to that location so you can view it under those lighting conditions, and mark-up your proof there to make your adjustments. If you don't know where you'll be displaying your prints (or you'll be displaying them in different locations), use the same viewing light source to eliminate the light source as a variable.

And soon you'll have it: The ultimate print that is ready to be matted and framed and displayed in gallery-quality style. It represents attention to the entire workflow of taking a photo and making a print. From choosing high quality equipment to employing the techniques that bring the most out of the equipment and the software procedures that draw out the last ounce of quality from your image file, you've achieved an amazing goal. Soon the process will become second nature. And then, when you come across a scene or subject that grabs your breath, you'll be able to create photographs and prints that are equally breathtaking.

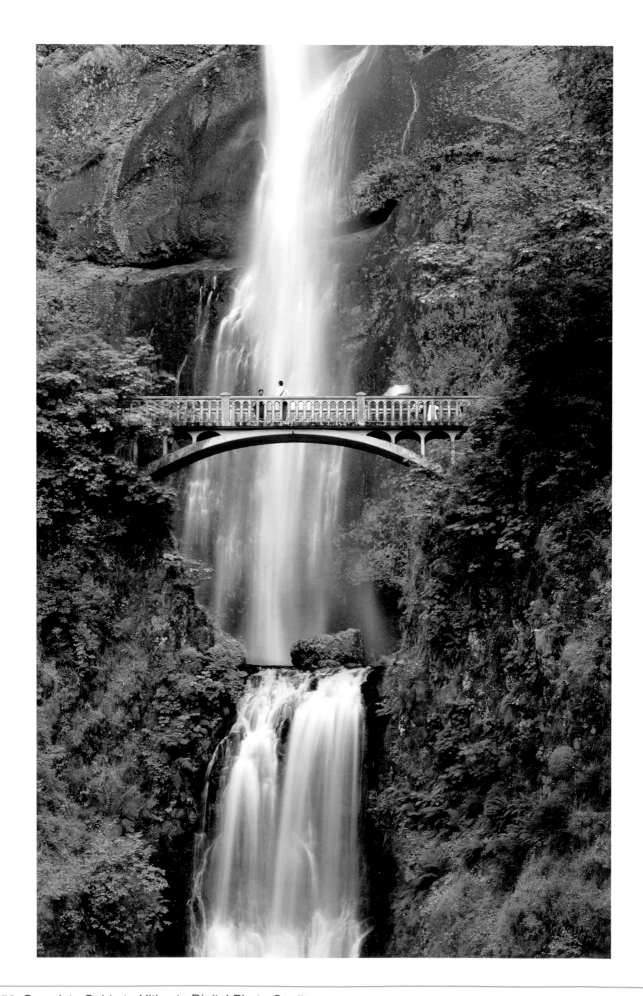

Glossary

aberration
An optical flaw in a lens that causes the image to be distorted or unclear.

Adobe Photoshop CSx
Professional-level image-processing software with extremely powerful filter and color-correction tools.

Adobe Photoshop Elements
This program has a comprehensive range of image-manipulation options, particularly in the Elements 5 version, though it lacks some of the more sophisticated controls available in Photoshop.

anti-aliasing
A technique that reduces or eliminates the jagged appearance of lines or edges in an image.

aperture
The opening in the lens that allows light to enter the camera. Aperture size is usually described with an f/number. The larger the f/number, the smaller the aperture; and the smaller the f/number, the larger the aperture.

Aperture Priority mode
A type of automatic exposure in which you manually select the aperture and the camera automatically sets the shutter speed.

artifact
Information that is not part of the scene but appears in the image due to technology.

artificial light
Usually refers to any light source that doesn't exist in nature, such as incandescent, fluorescent, and other manufactured lighting.

automatic exposure
When the camera measures light and makes the adjustments necessary to create proper image density on sensitized media.

automatic flash
An electronic flash unit that reads light reflected off a subject (from either a pre-flash or the actual flash exposure), then shuts itself off as soon as ample light has reached the sensitized medium.

automatic focus
When the camera automatically adjusts the lens elements to sharply render the subject.

available (ambient) light
The amount of illumination at a given location that applies to natural and artificial light sources but not those supplied specifically for photography. It is also called existing light or ambient light.

backlight
Light that projects toward the camera from behind the subject.

bit depth
The number of bits per pixel that determines the number of colors the image can display. Eight bits per pixel is the minimum requirement for a photo-quality color image.

bracketing
A sequence of pictures taken of the same subject but varying one or more exposure settings, manually or automatically, between each exposure. When provided automatically by the camera, it is called auto exposure bracketing. Some cameras can also bracket white balance.

brightness
A subjective measure of illumination. See also, luminance.

card reader
A device that connects to your computer and enables quick and easy download of images from memory card to computer.

chromatic aberration
Occurs when light rays of different colors are focused on different planes, causing colored halos around objects in the image.

chrominance
A component of an image that expresses the color (hue and saturation) information, as opposed to the luminance (lightness) values.

close-up
A general term used to describe an image created by closely focusing on a subject. Often involves the use of special lenses or extension tubes. Also, an automated exposure setting that automatically selects a large aperture (not available with all cameras).

color balance
The average overall color in a reproduced image. How a digital camera interprets the color of light in a scene so that white or neutral gray appear neutral.

color cast
A colored hue over the image often caused by improper lighting or incorrect white balance settings. Can be produced intentionally for creative effect.

color space
A mapped relationship between colors and computer data about the colors. The sRGB color space is employed by most cameras although many D-SLRs can also use the Adobe RGB color space with its wider color gamut (recording range) that is useful when making inkjet prints.

color temperature
A numerically expressed value, usually in degrees Kelvin, to communicate the color of the light illuminating a subject. A high number denotes a bluish (colder) color while a low number denotes a reddish (warmer) color. Many digital cameras include a color temperature adjustment as one of the white balance options.

CompactFlash (CF) card
A widely used type of removable memory cards.

compression
A method of reducing file size through removal of redundant data, as with the JPEG file format.

contrast
The difference between two or more tones in terms of luminance, density, or darkness.

critical focus
The most sharply focused plane within an image.

cropping
The process of extracting a portion of the image area.

dedicated flash
An electronic flash unit that talks with the camera, communicating data such as flash illumination, lens focal length, subject distance, and reflectivity, and sometimes flash status.

depth of field
The image space in front of and behind the plane of focus that appears acceptably sharp in the photograph.

digital zoom
The cropping of the image at the sensor to create the effect of a telephoto zoom lens. The camera interpolates the image to the original resolution. However, the result is not as sharp as an image created with an optical zoom lens because the cropping of the image reduced the available sensor resolution.

electronic flash
A device with a glass or plastic tube filled with gas that, when electrified, creates an intense flash of light. Also called a strobe in conversational terms.

exposure
When light enters the camera and reacts with the sensitized medium. The term can also refer to the amount of light that strikes the light sensitive medium.

exposure compensation
An in-camera feature that allows for increasing image brightness (with a plus setting) or decreasing image brightness (with a minus setting).

extension tube
A hollow metal ring that can be fitted between the camera and lens. It increases the distance between the optical center of the lens and the sensor and decreases the minimum focus distance of the lens.

file format
The form in which digital images are stored and recorded, e.g., JPEG, RAW, TIFF, etc.

filter
Usually a piece of plastic or glass used to control how certain wavelengths of light are recorded. A filter absorbs selected wavelengths, preventing them from reaching the light sensitive medium. Also, software available in image-processing computer programs can produce special filter effects.

firmware
Software that is permanently incorporated into a hardware chip. All computer-based equipment, including digital cameras, use firmware of some kind. Camera manufacturers sometimes announce firmware upgrades available free of charge.

flare
Unwanted light streaks or rings that appear in the viewfinder, on the recorded image, or both. It is caused by extraneous light entering the camera during shooting. Use of a lens hood can often reduce this undesirable effect.

focal length
When the lens is focused on infinity, it is the distance from the optical center of the lens to the focal plane.

focal plane
The plane on which a lens forms a sharp image. Also, it may be the film plane or sensor plane.

focus

An optimum sharpness or image clarity that occurs when a lens creates a sharp image by converging light rays to specific points at the focal plane. The word also refers to the act of adjusting the lens to achieve optimal image sharpness.

f/stop

The size of the aperture or diaphragm opening of a lens, also referred to as f/number or stop. The term stands for the ratio of the focal length (f) of the lens to the width of its aperture opening. (f/1.4 = wide opening and f/22 = narrow opening.) Each stop up (lower f/number) doubles the amount of light reaching the sensitized medium. Each stop down (higher f/number) halves the amount of light reaching the sensitized medium.

full-frame

The maximum area covered by the sensitized medium.

full-sized sensor

A sensor in a digital camera that has the same dimensions as a 35mm film frame (24 x 36 mm).

gigabyte (GB)

Just over one billion bytes.

gray scale

A successive series of tones ranging between black and white, which have no color.

guide number (GN)

A number used to quantify the output of a flash unit. It is derived by using this formula: GN = aperture x distance. Guide numbers are expressed for a given ISO in either feet or meters.

histogram

A representation of image tones in a graph format.

hot shoe

An electronically connected flash mount on the camera body. It enables direct connection between the camera and an external flash, and synchronizes the shutter release with the firing of the flash.

image-processing program

Software that allows for image alteration and enhancement.

ISO

A term for industry standards from the International Organization for Standardization. When an ISO number is applied to film, it indicates the relative light sensitivity of the recording medium. Digital sensors use film ISO equivalents, which are based on enhancing the data stream or boosting the signal.

JPEG
Joint Photographic Experts Group. This is a lossy compression file format that works with any computer and photo software. JPEG examines an image for redundant information and then removes it. At low compression/high quality, the loss of data has a negligible effect on the photo. However, JPEG should not be used as a working format in a computer—the file should be reopened and saved in a format such as TIFF, which does not compress the image or uses "lossless" compression.

LCD
Liquid Crystal Display, which is a flat screen with two clear polarizing sheets on either side of a liquid crystal solution. When activated by an electric current, the LCD causes the crystals to either pass through or block light in order to create a colored image display.Used in a digital camera to display information about camera settings and to review recorded images (in a D-SLR).

lens
A piece of optical glass on the front of a camera that has been precisely calibrated to allow focus.

lens hood
Also called a lens shade. This is a short tube that can be attached to the front of a lens to reduce flare. It keeps undesirable light from reaching the front of the lens and also protects the front of the lens.

light meter
A device that measures light levels and calculates an appropriate aperture and shutter speed.

macro lens
A lens designed for extremely close focusing and high magnification (usually to 1x, also called a 1:1 reproduction ratio) with superior image quality in such applications.

manual mode (M)
A camera operating mode that requires the user to determine and set both the aperture and shutter speed. This is the opposite of automatic exposure.

megabyte (MB)
Just over one million bytes.

megapixel (MP)
A million pixels.

memory card
A solid state removable storage medium that can store still images, moving images, or sound, as well as related file data. There are several different types, including SD and CompactFlash.

menu
A listing of features, functions, or options displayed on a screen that can be selected and activated by the user.

middle gray
Halfway between black and white, it is an average gray tone with 18% reflectance. See also, gray card.

midtone
The tone that appears as medium brightness, or medium gray tone, in a photographic print.

moiré
Occurs when the subject has more detail than the resolution of the digital camera can capture. Moiré appears as a wavy pattern over the image.

noise
The digital equivalent of grain. It is often caused by a number of different factors, such as a high ISO setting, heat, sensor design, etc. Though usually undesirable, it may be added for creative effect using an image-processing program. See also, chrominance noise and luminance.

normal lens
See standard lens.

overexposed
When too much light is recorded with the image, causing the photo to be too light in tone.

pan
Moving the camera to follow a moving subject. When a slow shutter speed is used, this creates an image in which the subject appears sharp and the background is blurred.

perspective
The effect of the distance between the camera and image elements upon the perceived size of objects in an image. It is also an expression of this three-dimensional relationship in two dimensions.

pincushion distortion
A flaw in a lens that causes straight lines to bend inward toward the middle of an image.

pixel
The base component of a digital image. Every individual pixel can have a distinct color and tone.

plug-in
Third-party software created to augment an existing software program.

RAW
An image file format (usually proprietary to a camera manufacturer) that has little or no internal processing applied by the camera. It contains 12-bit color information, a wider range of data than 8-bit formats such as JPEG.

RAW+JPEG
An image file format that records two files per capture; one RAW file and one JPEG file.

resolution
The amount of data available for an image as applied to image size. It is expressed in pixels or megapixels, or sometimes as lines per inch on a monitor or dots per inch on a printed image.

RGB
Red, Green, and Blue. This is the color model most commonly used to display color images on video systems, film recorders, and computer monitors. It displays all visible colors as combinations of red, green, and blue. RGB mode is the most common color mode for viewing and working with digital files onscreen.

saturation
The degree to which a color of fixed tone varies from the neutral, grey tone; low saturation produces pastel shades whereas high saturation gives pure color.

Sensitivity
See ISO.

shutter
The apparatus that controls the amount of time during which light is allowed to reach the light sensitive medium.

Shutter Priority mode
An automatic exposure mode in which you manually select the shutter speed and the camera automatically sets an appropriate aperture.

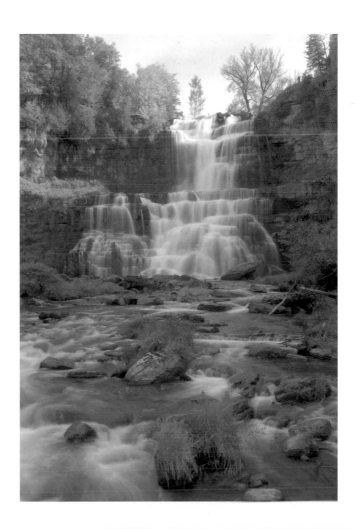

single-lens reflex
See SLR.

SLR
Single-lens reflex. A camera with a mirror that reflects the image entering the lens through a pentaprism or pentamirror onto the viewfinder screen. When you take the picture, the mirror reflexes out of the way (moving into an up position), the focal plane shutter opens, and the image is recorded.

standard lens
Also known as a normal lens, this is a fixed-focal-length lens of approximately 35mm for most D-SLRs. In contrast to wide-angle or telephoto lenses, a standard lens views a realistically proportionate perspective of a scene.

synchronize
Causing a flash unit to fire simultaneously with the complete opening of the camera's shutter.

telephoto lens
A lens with a long focal length that enlarges the subject and produces a narrower angle of view than you would see with your eyes.

TIFF
Tagged Image File Format. This digital format uses no compression and is popular for use in a computer. It will not affect when opened and resaved repeatedly

tripod
A three-legged stand that stabilizes the camera and eliminates camera shake caused by body movement or vibration. Tripods are usually adjustable for height and angle.

TTL
Through-the-Lens, i.e. TTL metering.

white balance
A control to adjust color temperature to match the color of the light source; ideally, the image should be accurate without a color cast.

vignetting
A reduction in light at the edge of an image due to use of a filter or an inappropriate lens hood for the particular lens.

wide-angle lens
A lens that produces a greater angle or field of view than you would see with your eyes, often causing the image to appear stretched.

Wi-Fi
Wireless fidelity, a technology that allows for wireless networking between one Wi-Fi compatible product and another.

zoom lens
A lens that can be adjusted to cover a wide range of focal lengths.

Index